THE
Adorable
CIRCLE OF LIFE
Adult Coloring Book

Skyhorse Publishing books may be purchased in bulk at special discounts for sales promotion, corporate gifts, fund-raising, or educational purposes. Special editions can also be created to specifications. For details, contact the Special Sales Department, Skyhorse Publishing, 307 West 36th Street, 11th Floor, New York, NY 10018 or info@skyhorsepublishing.com.

Skyhorse® and Skyhorse Publishing® are registered trademarks of Skyhorse Publishing, Inc.®, a Delaware corporation.

Visit our website at www.skyhorsepublishing.com.

10 9 8 7 6 5 4 3 2

Cover illustration and design by the author

Print ISBN: 978-1-5107-1574-5

Printed in China

THE Adorable
CIRCLE OF LIFE
Adult Coloring Book

Alex Solis

Skyhorse Publishing

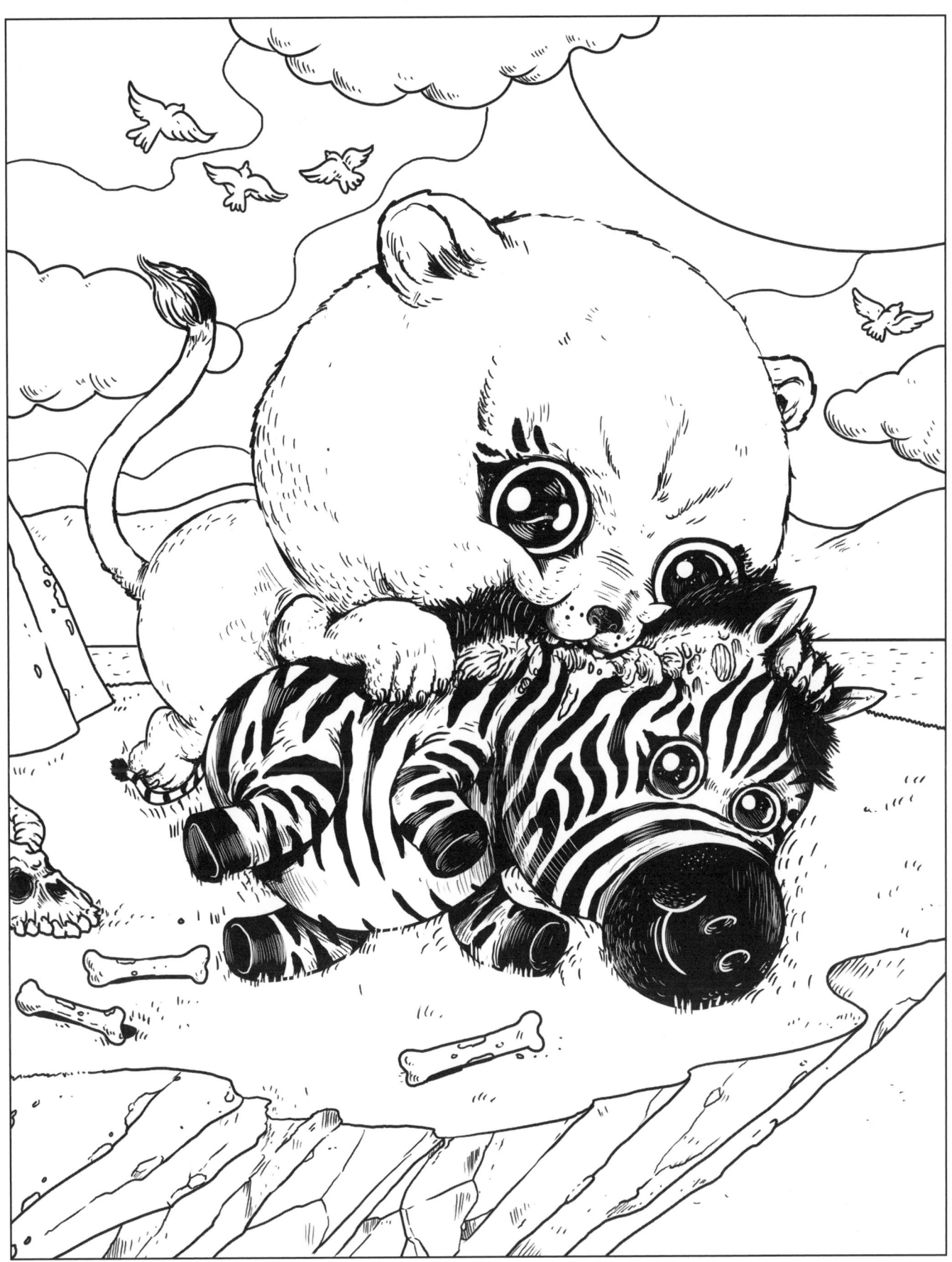

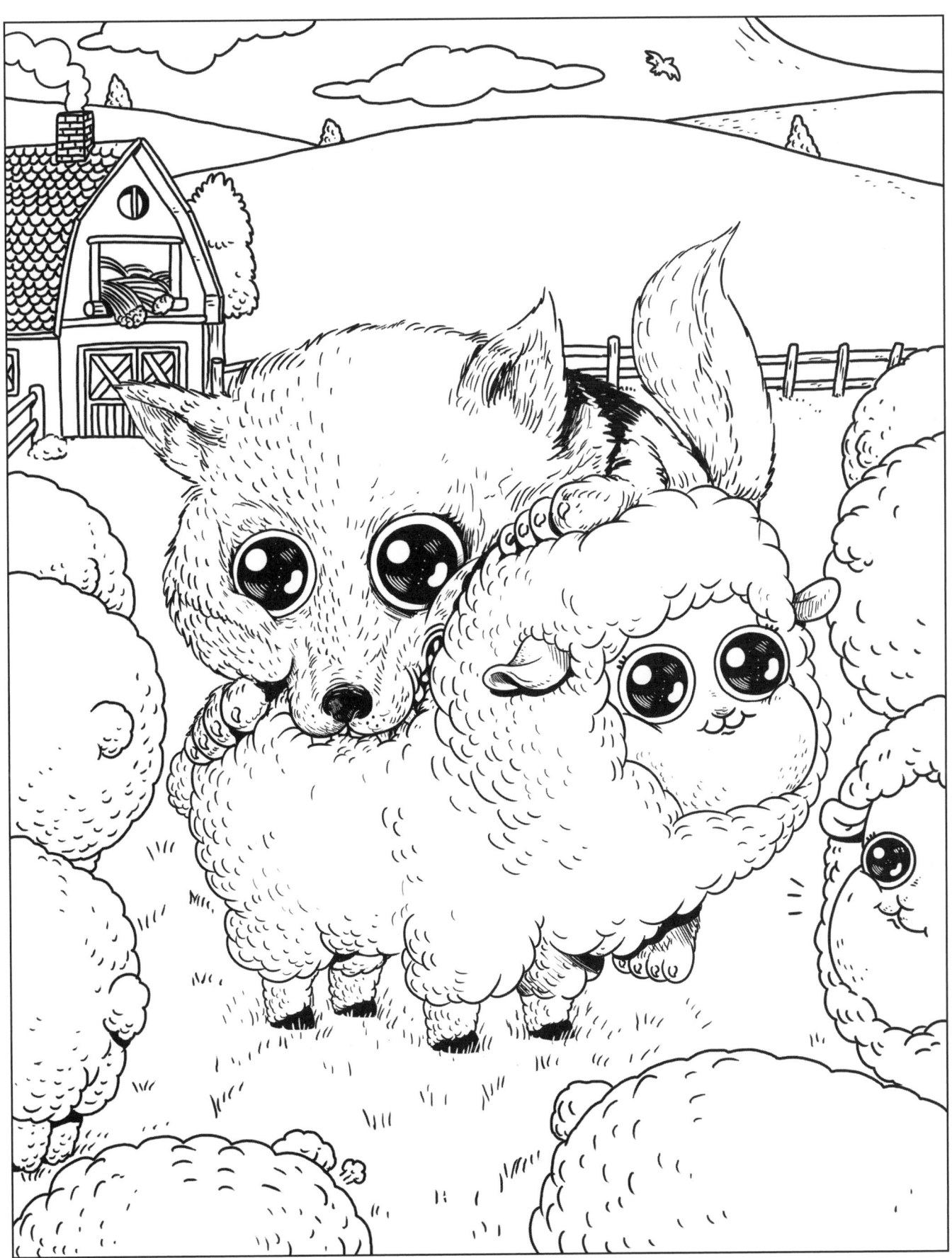

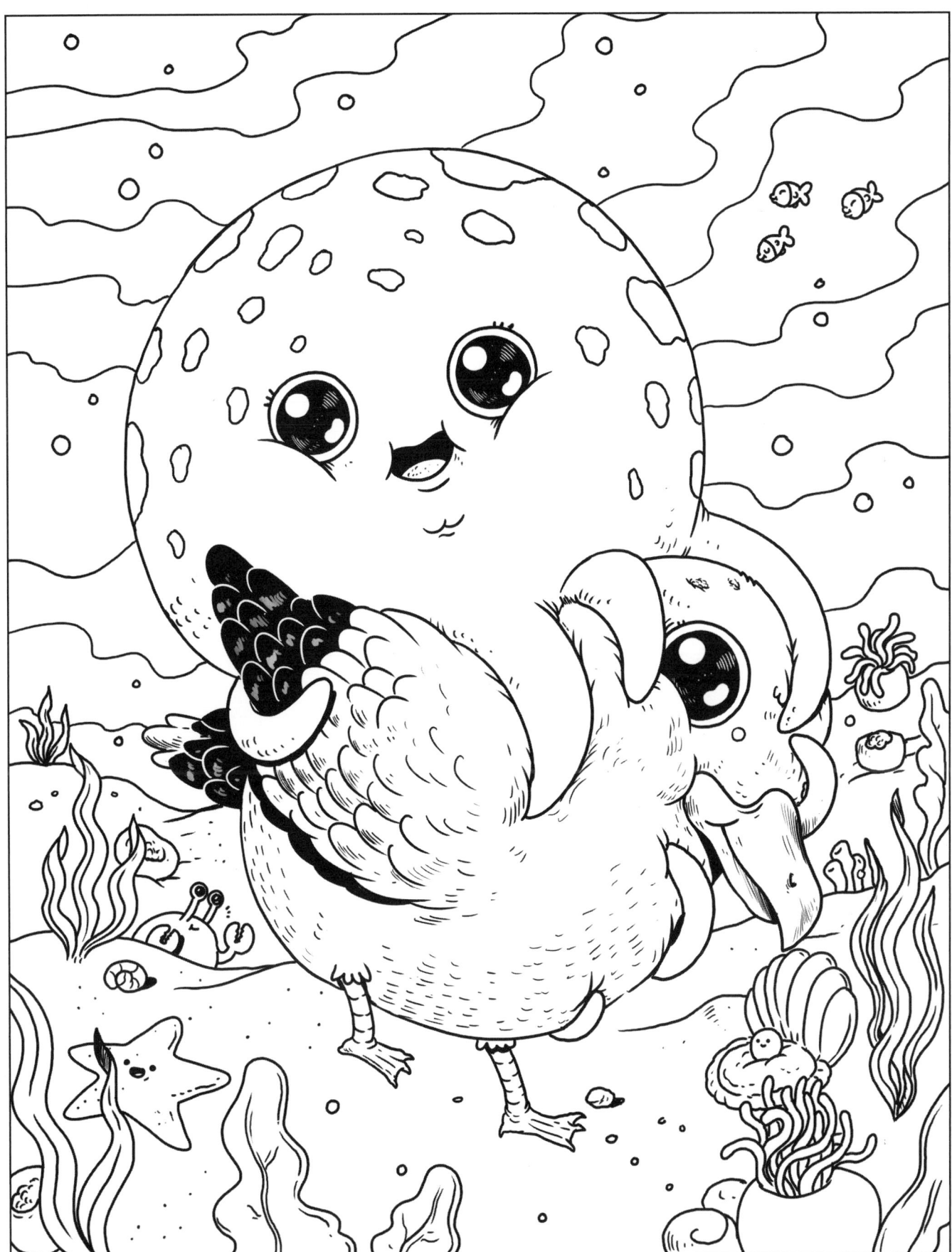

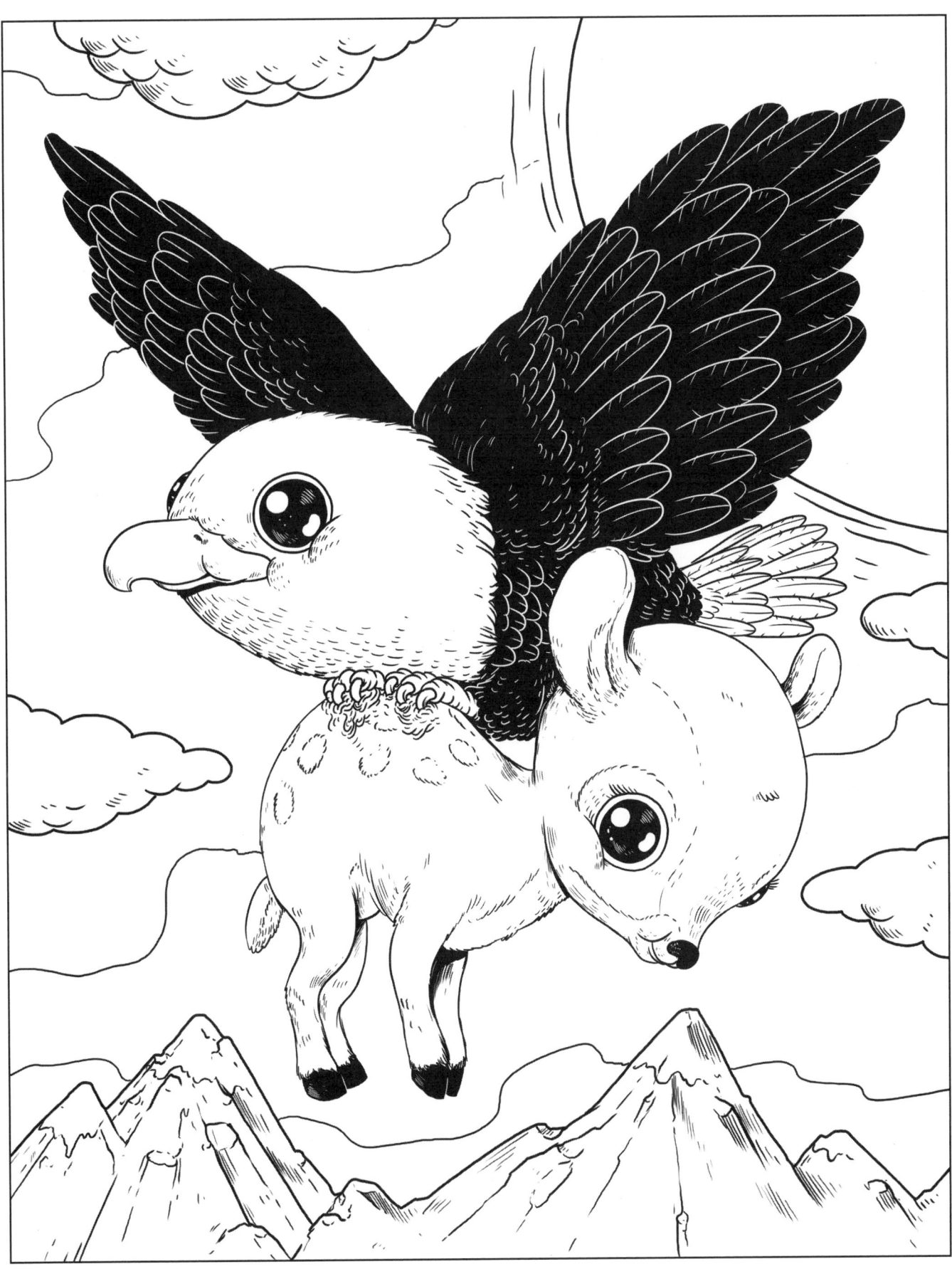

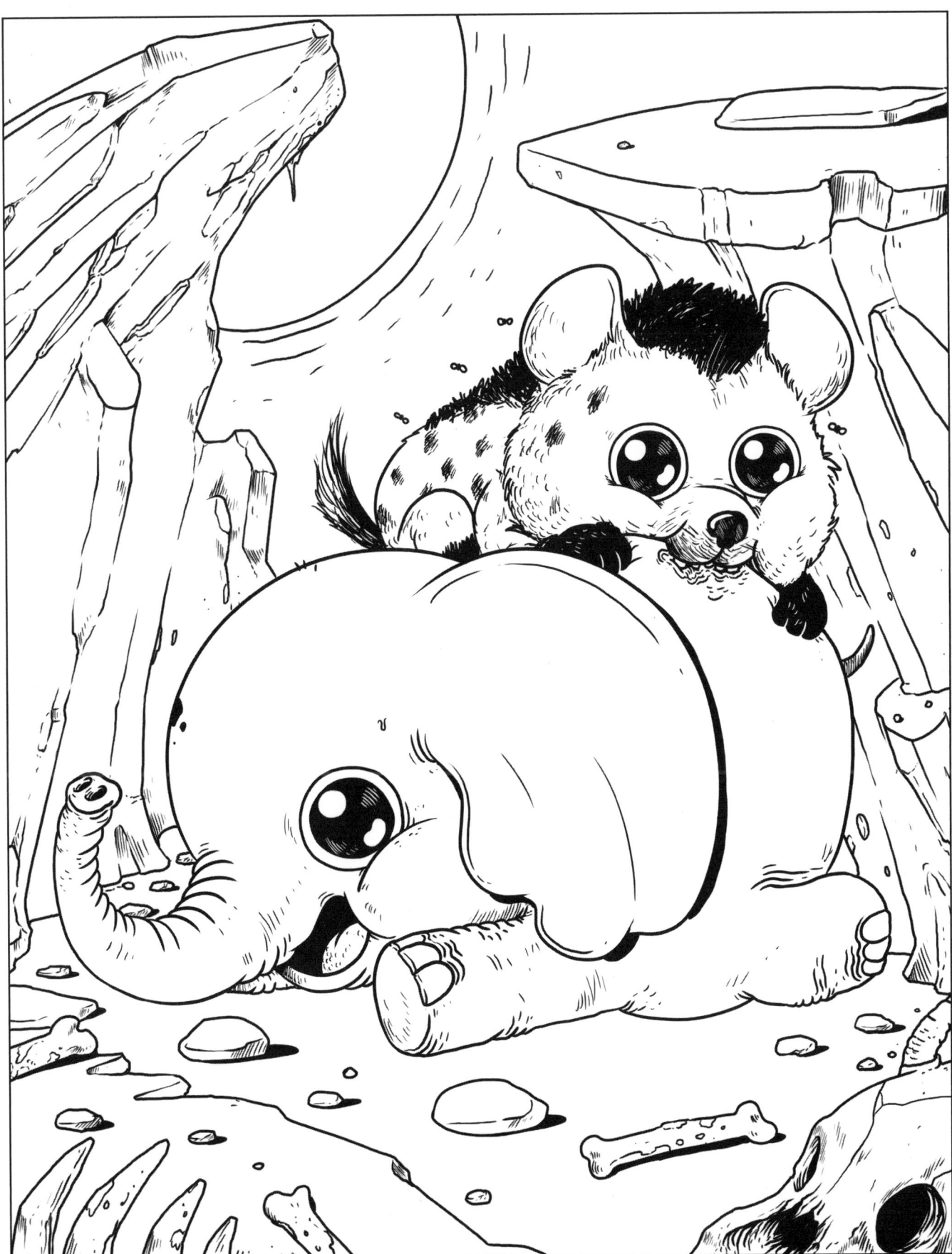

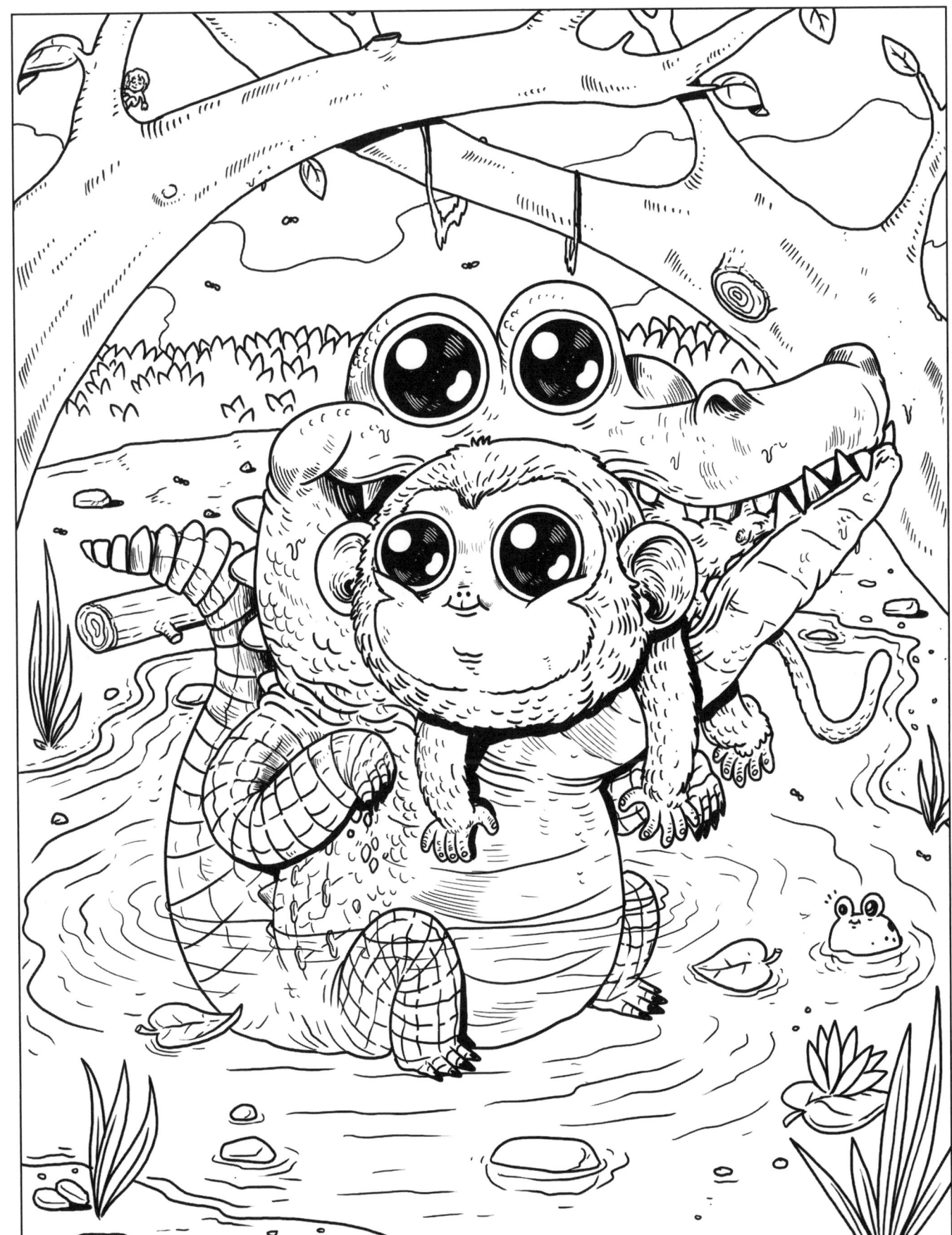

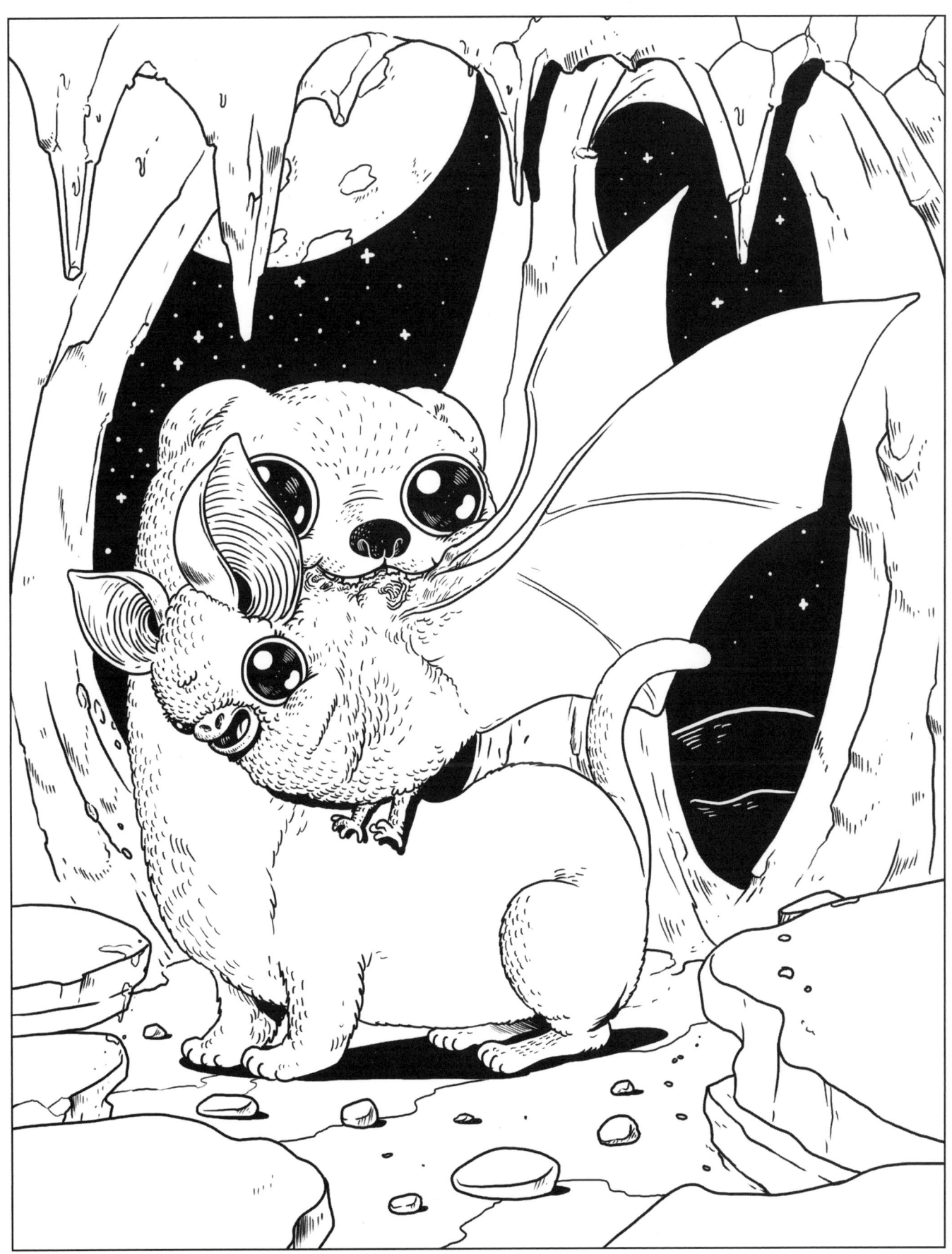

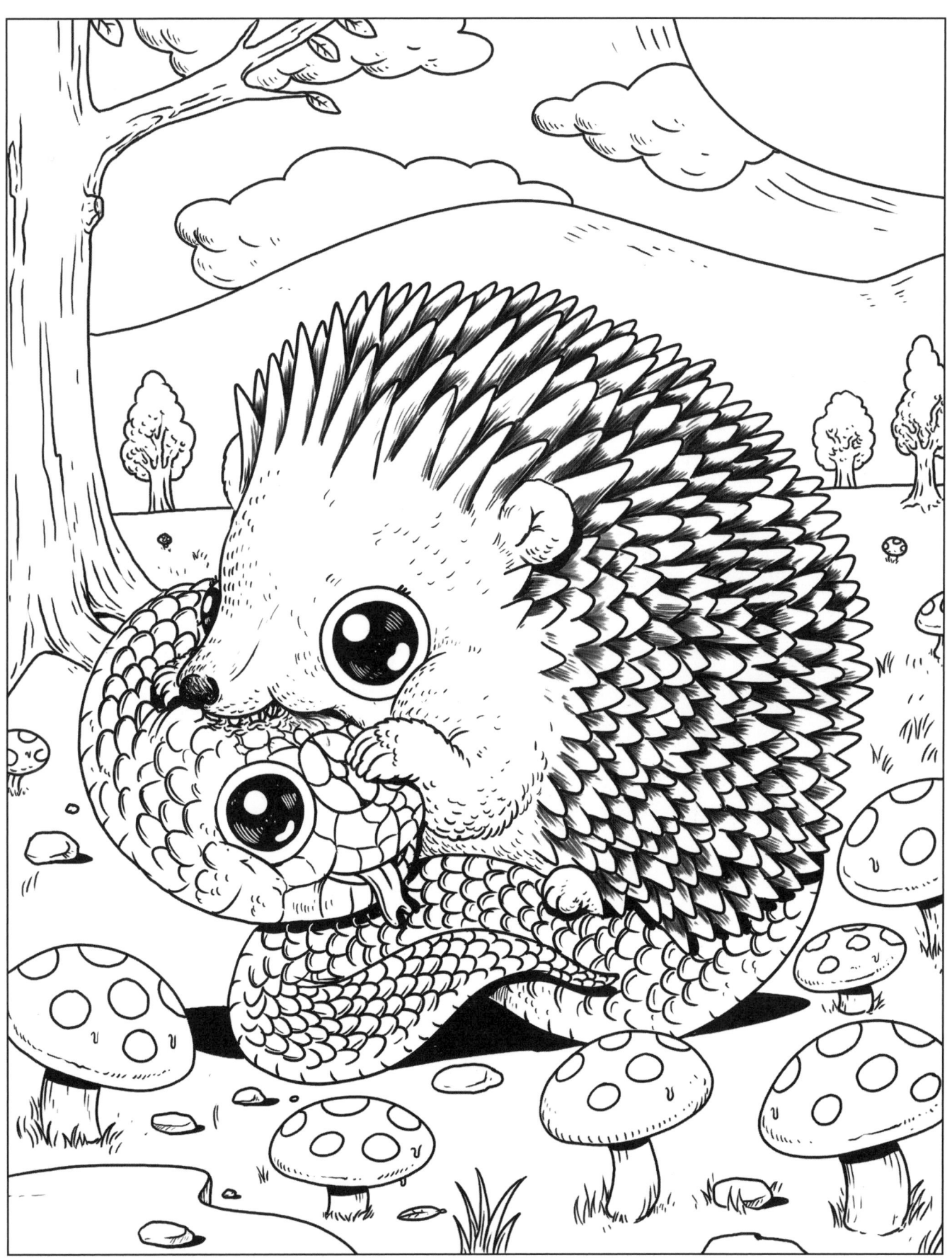

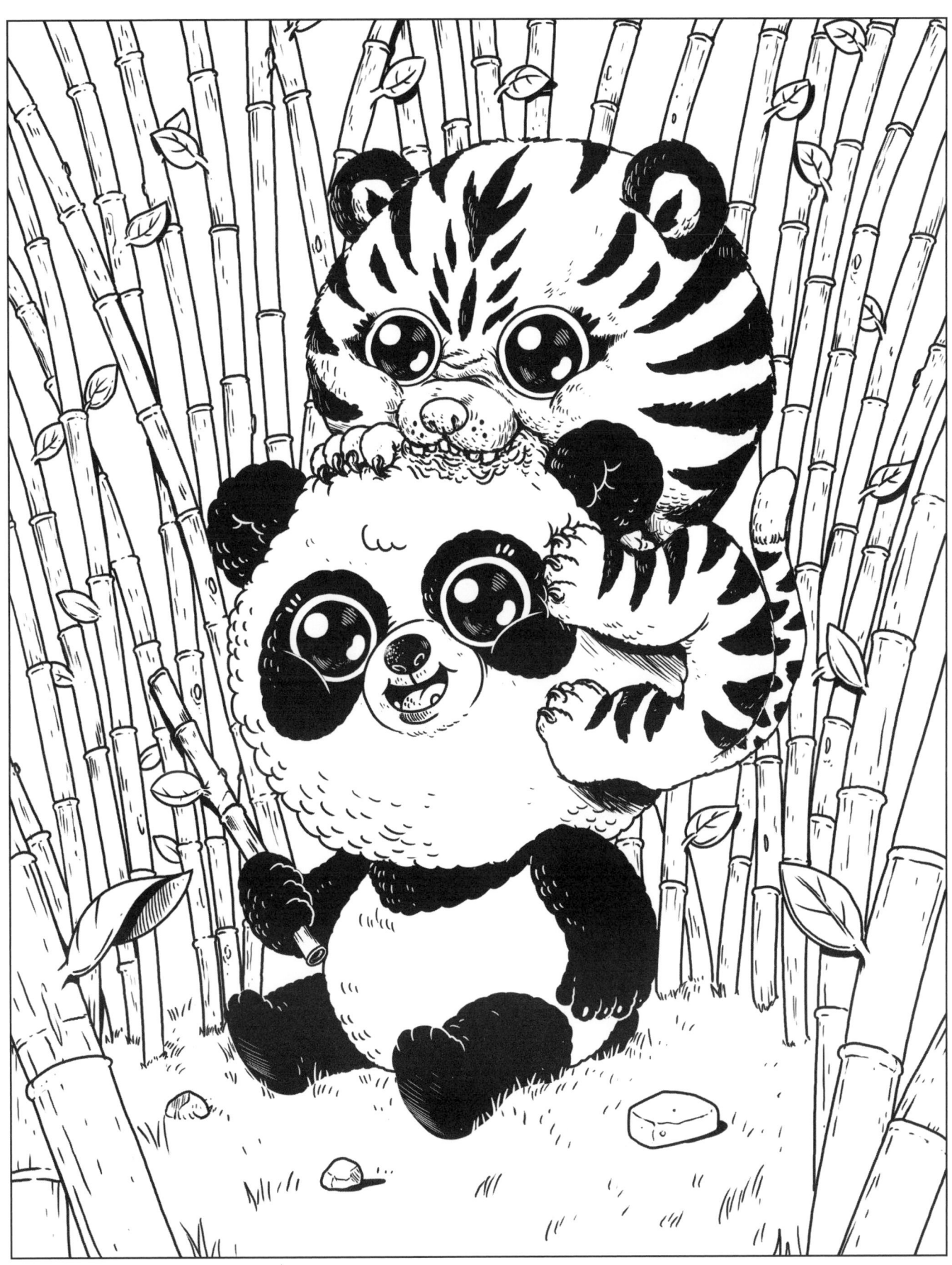

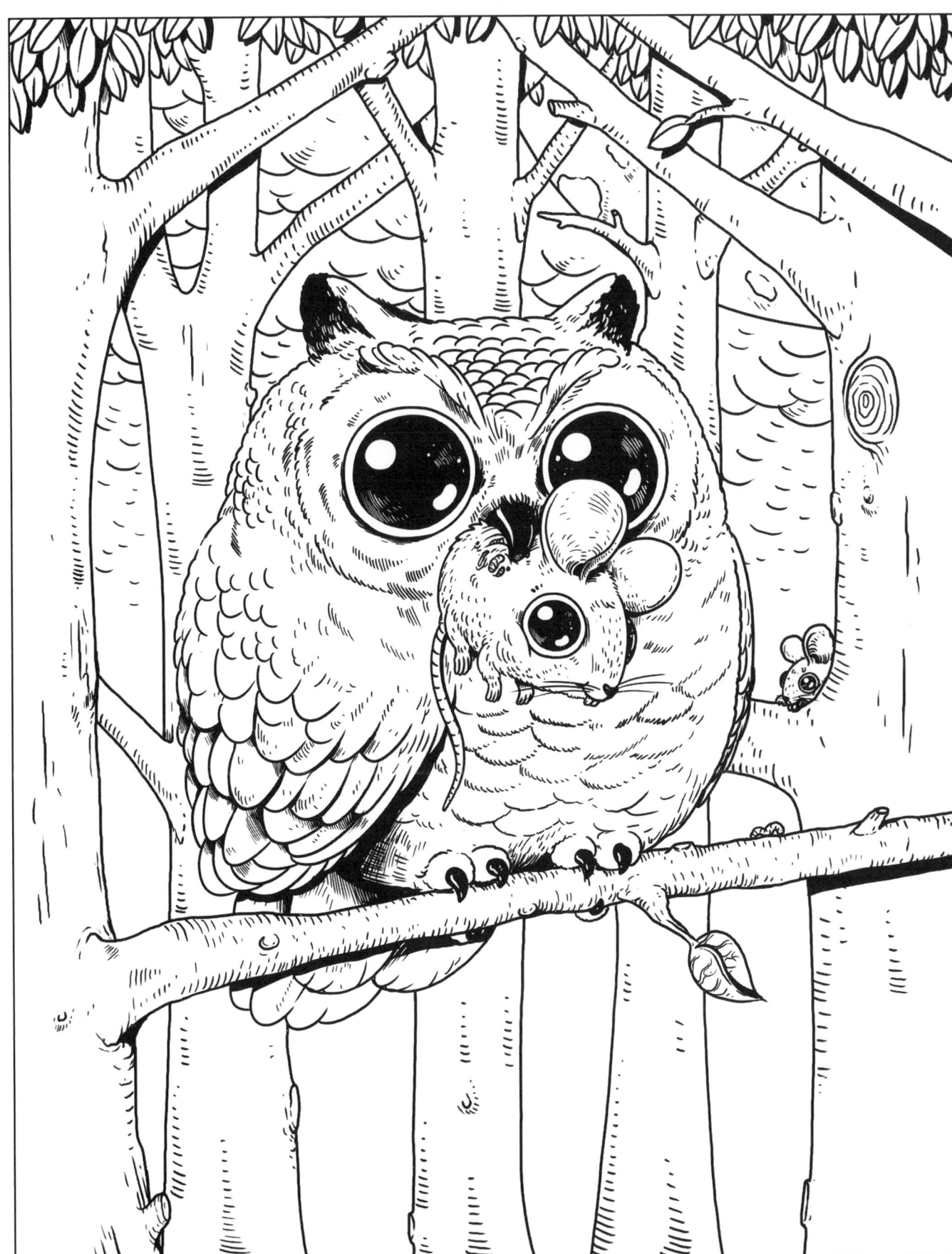

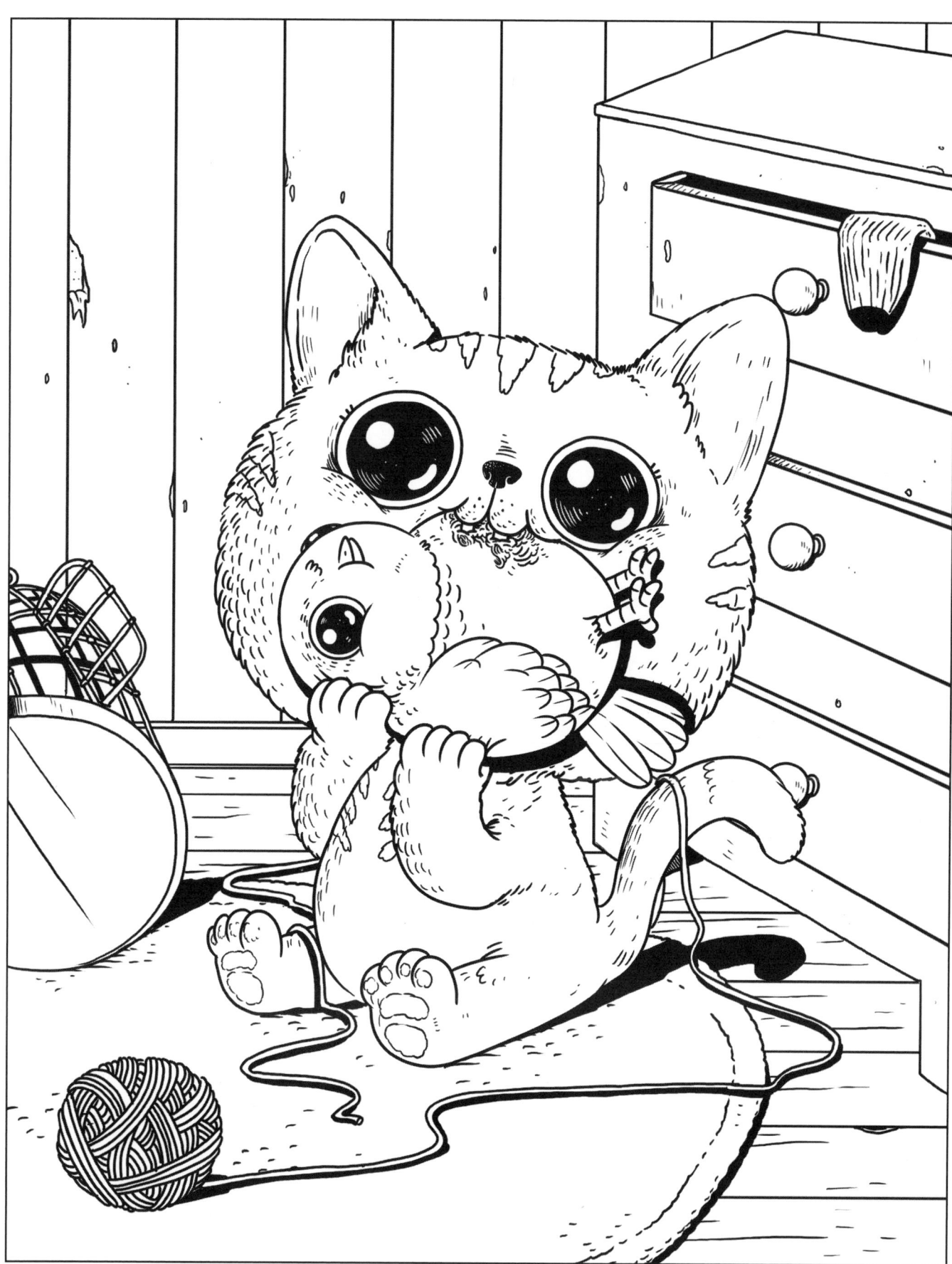

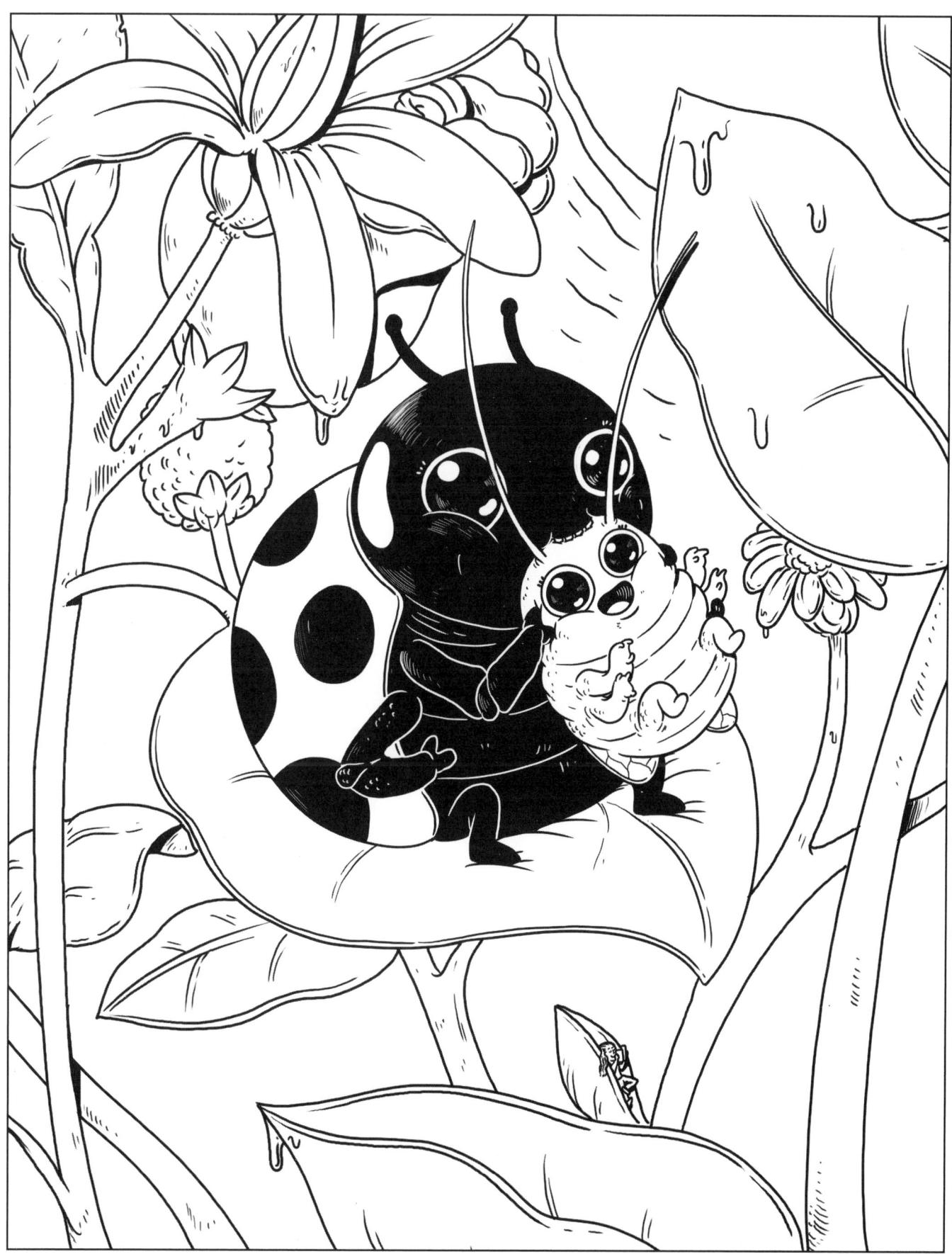

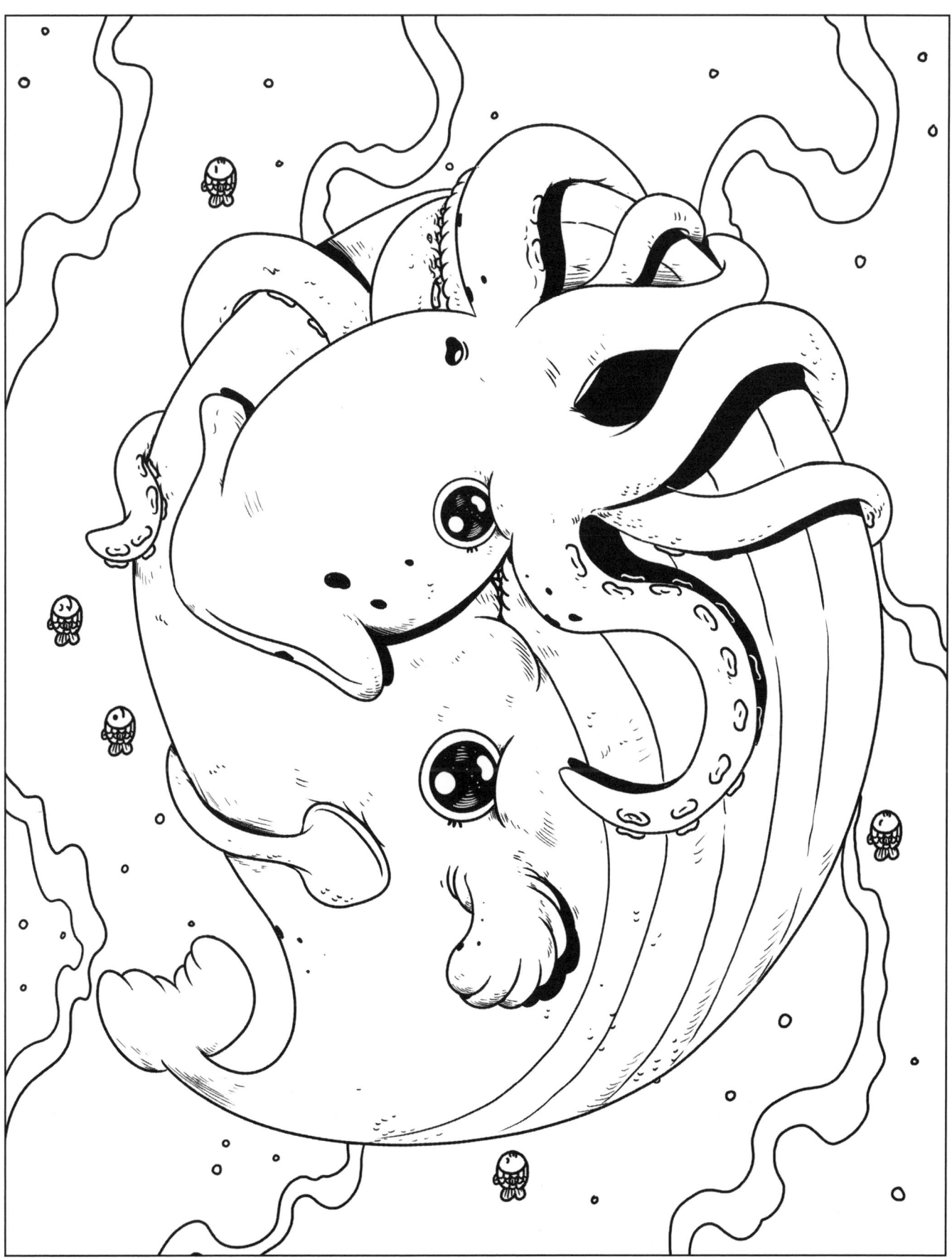

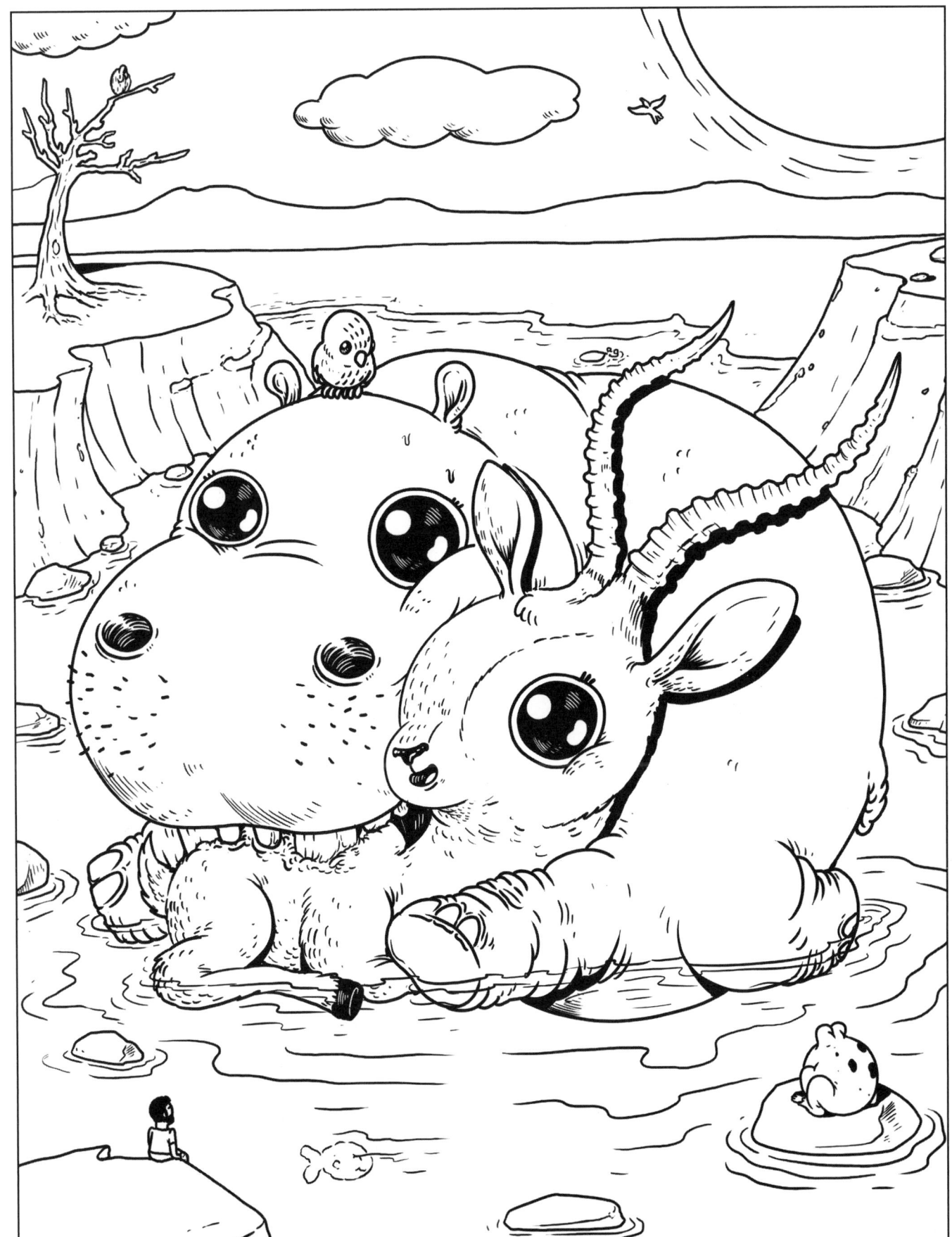

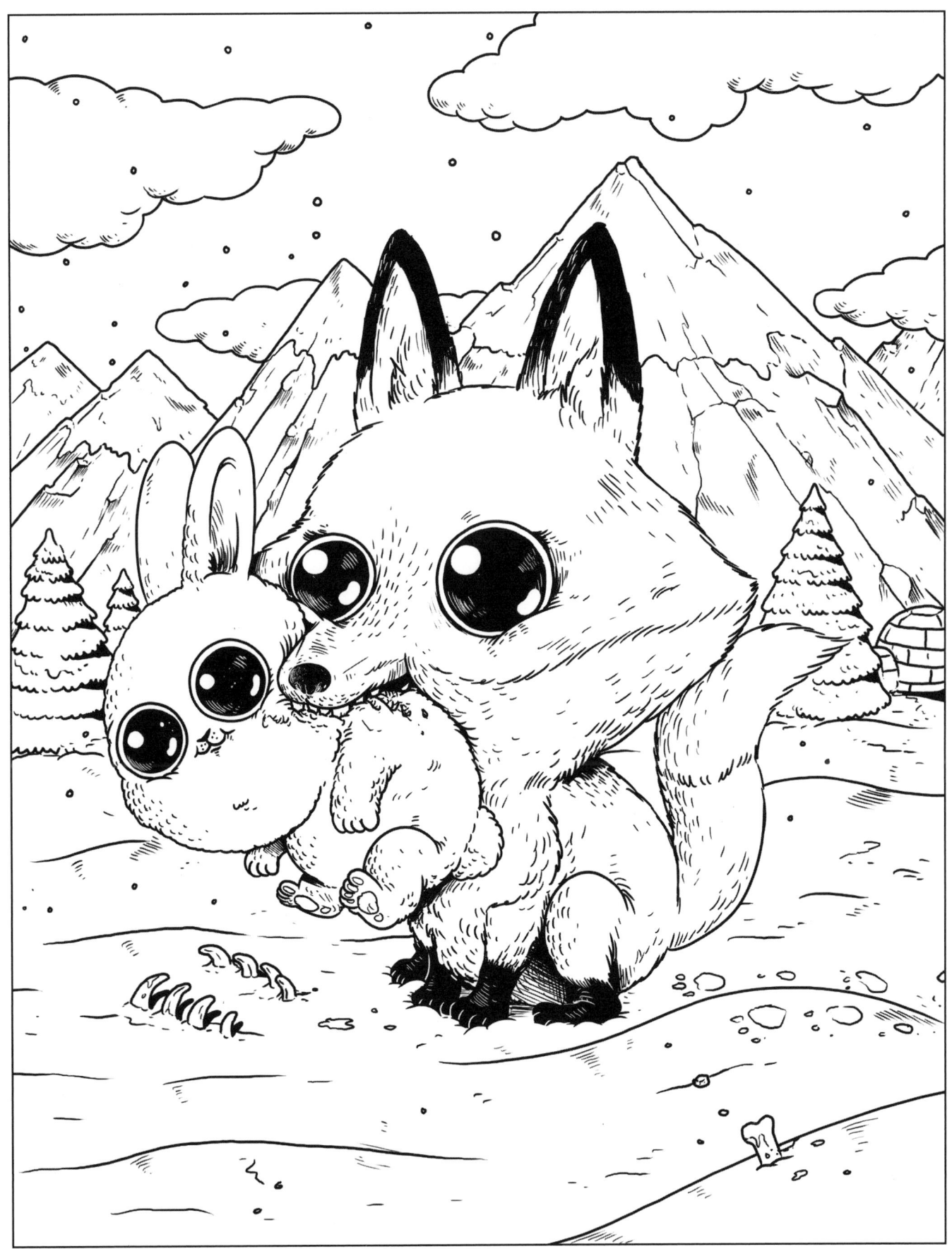

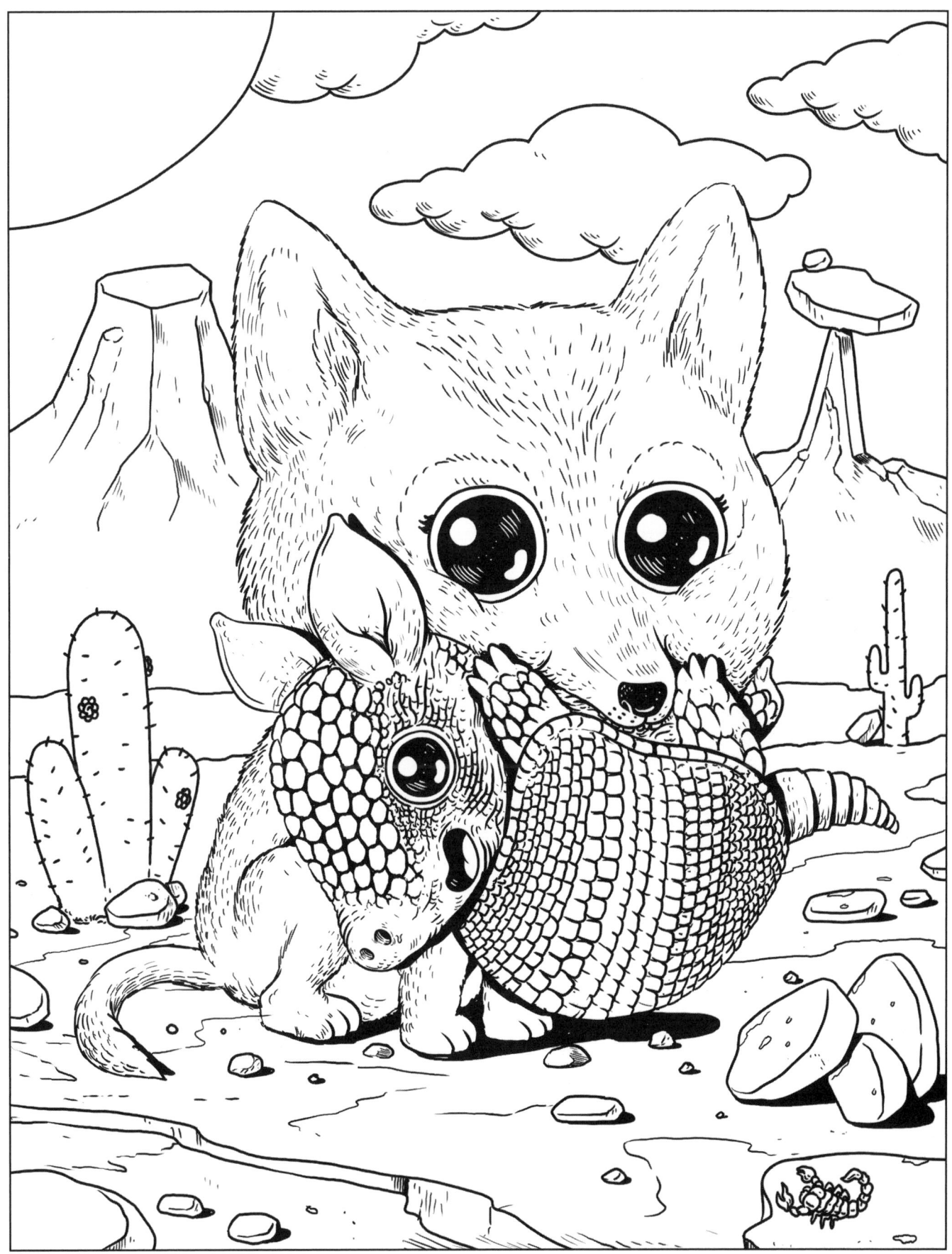

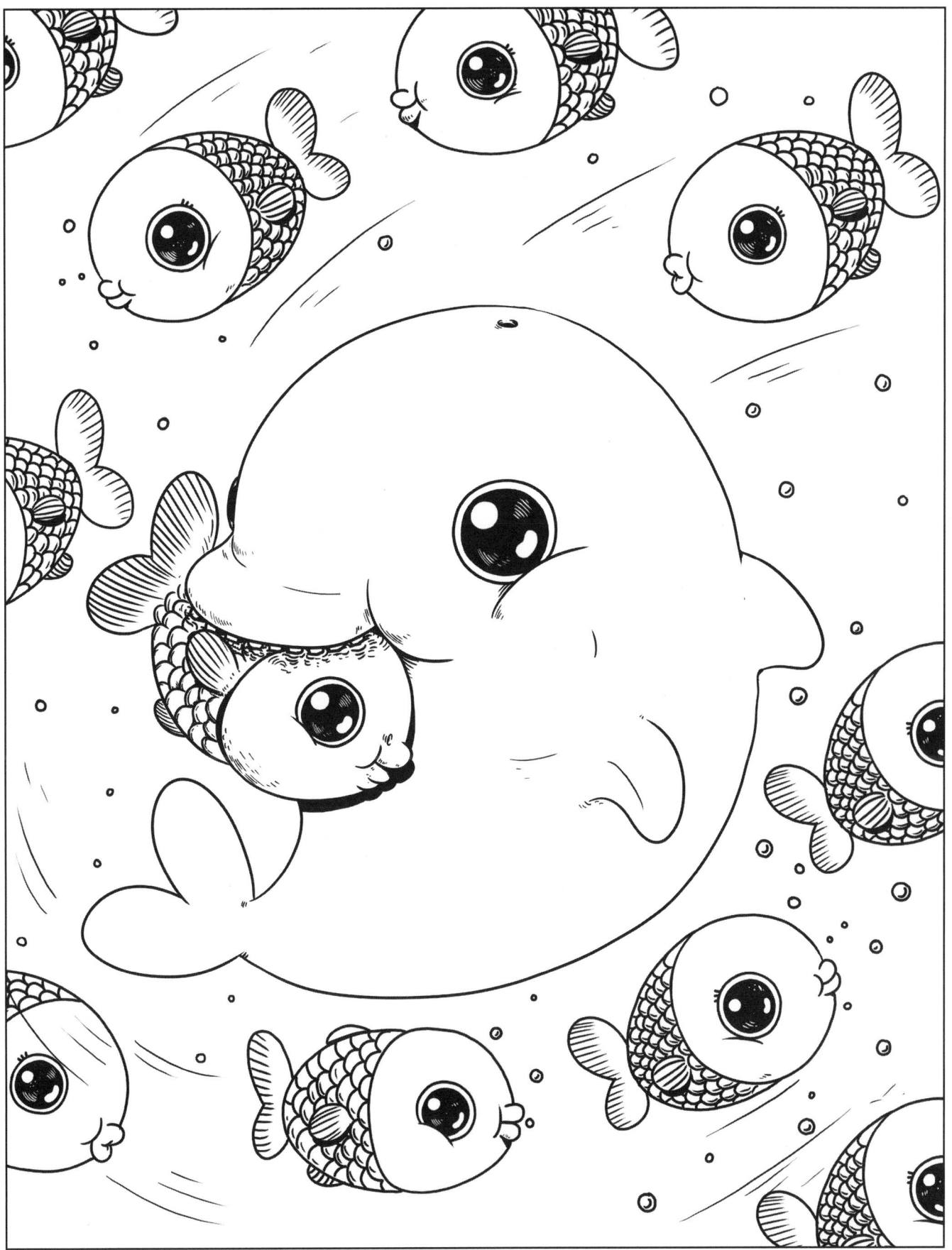

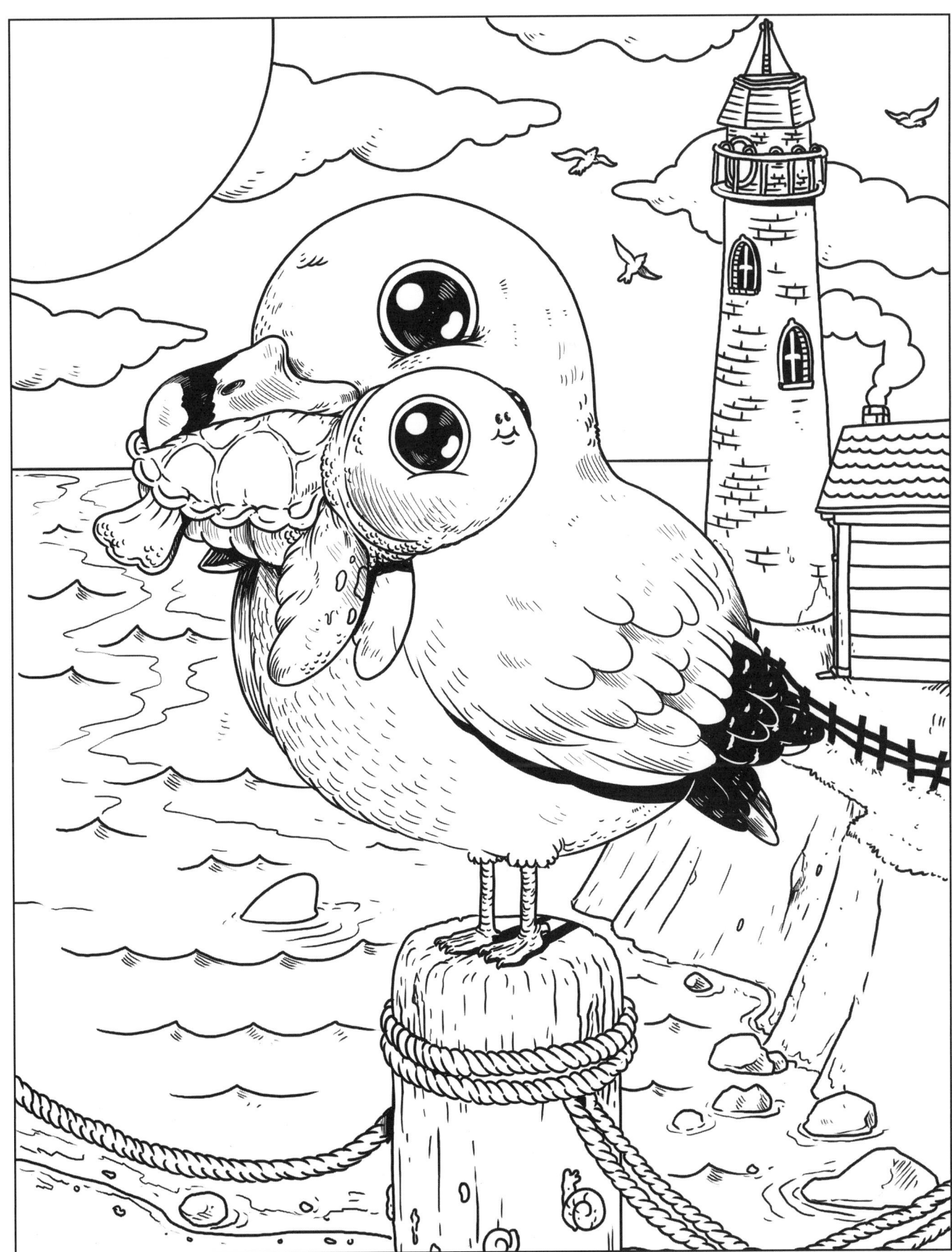

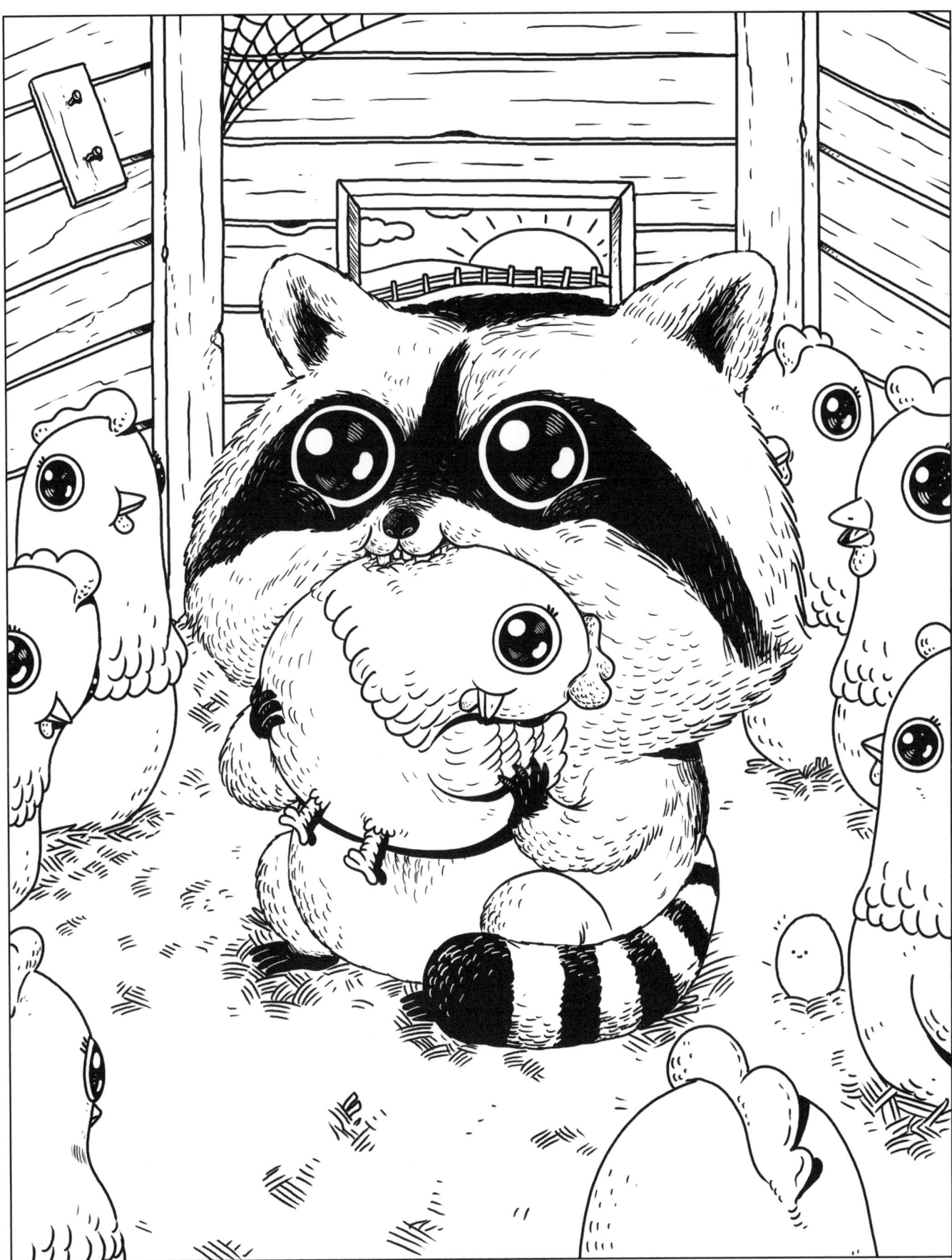

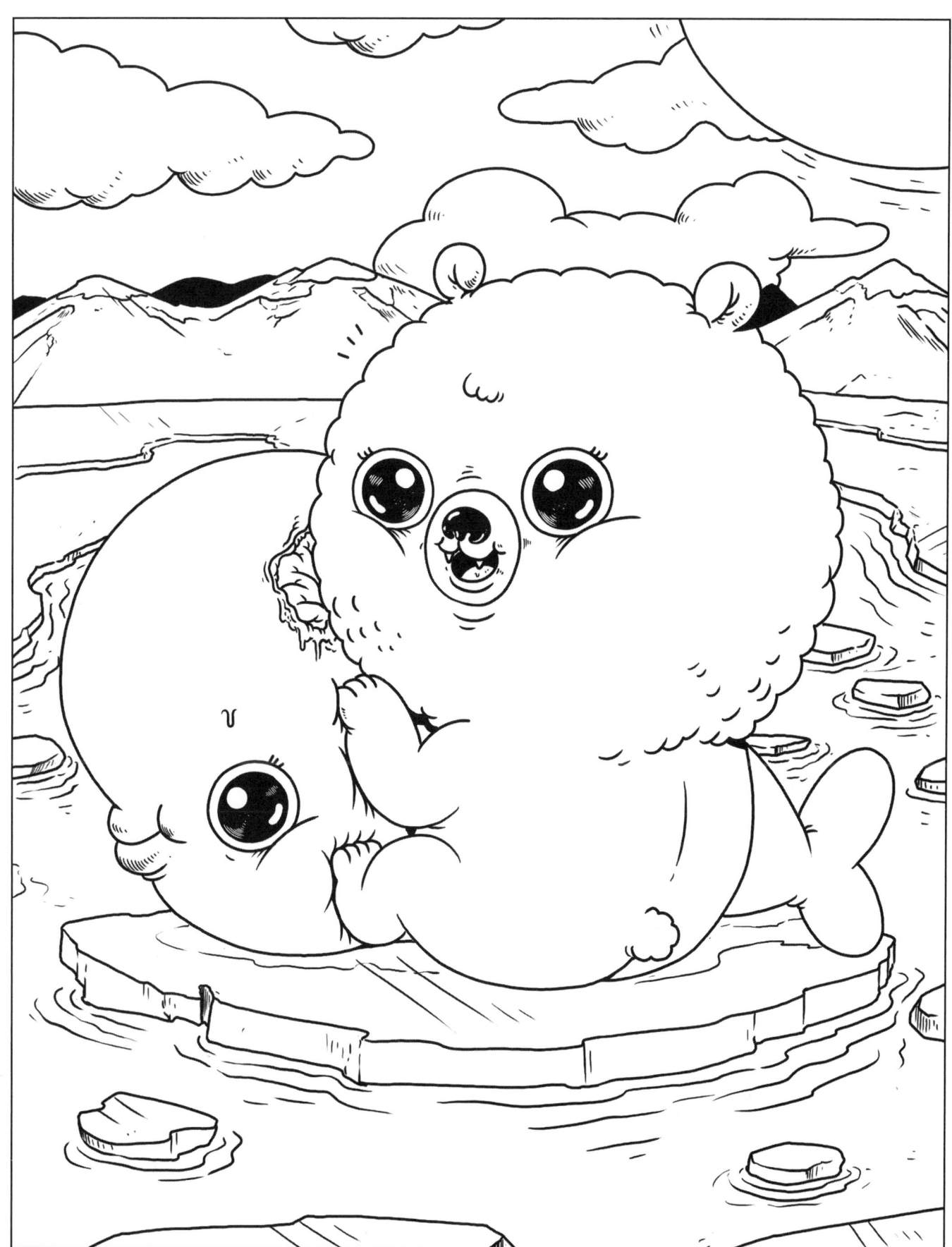

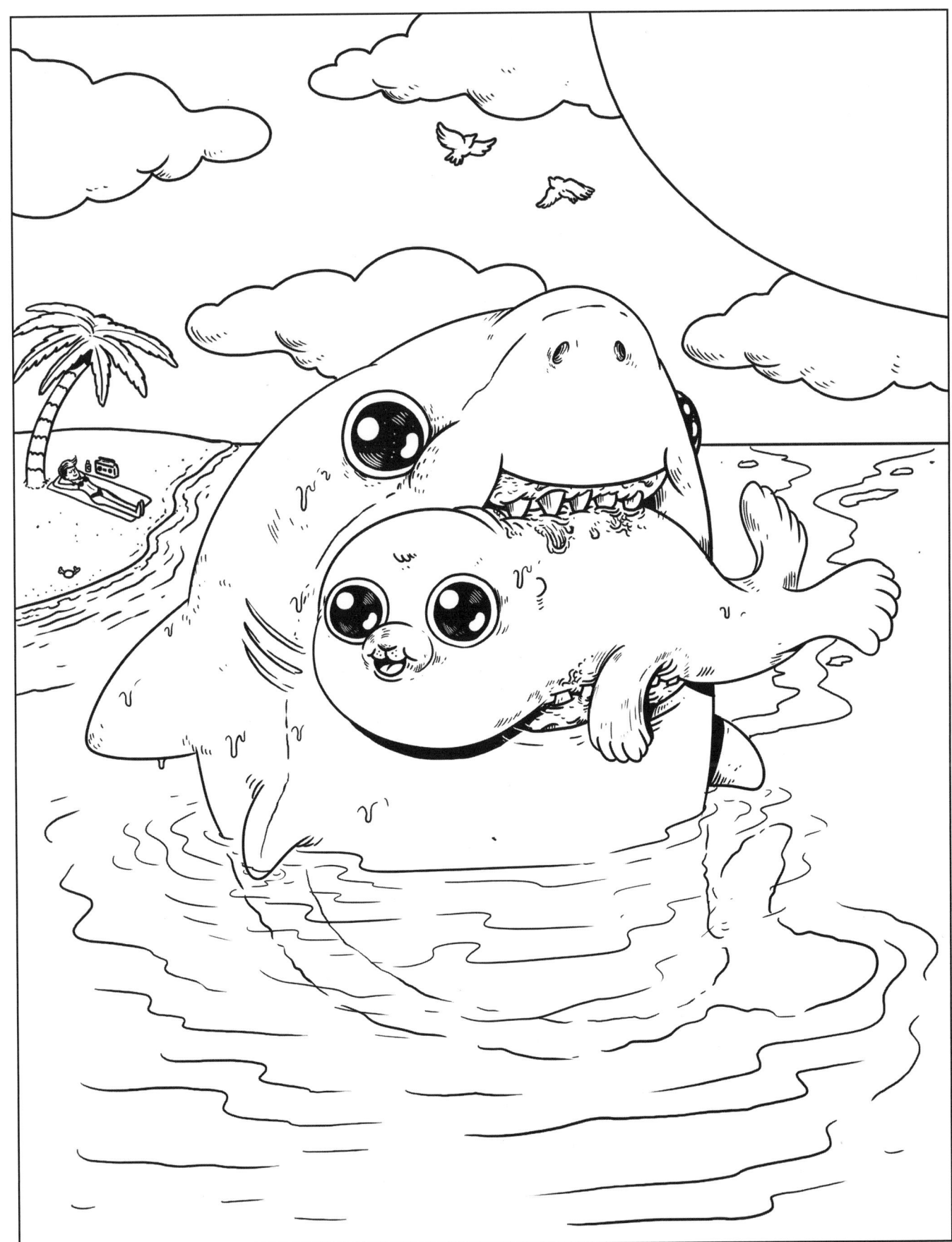

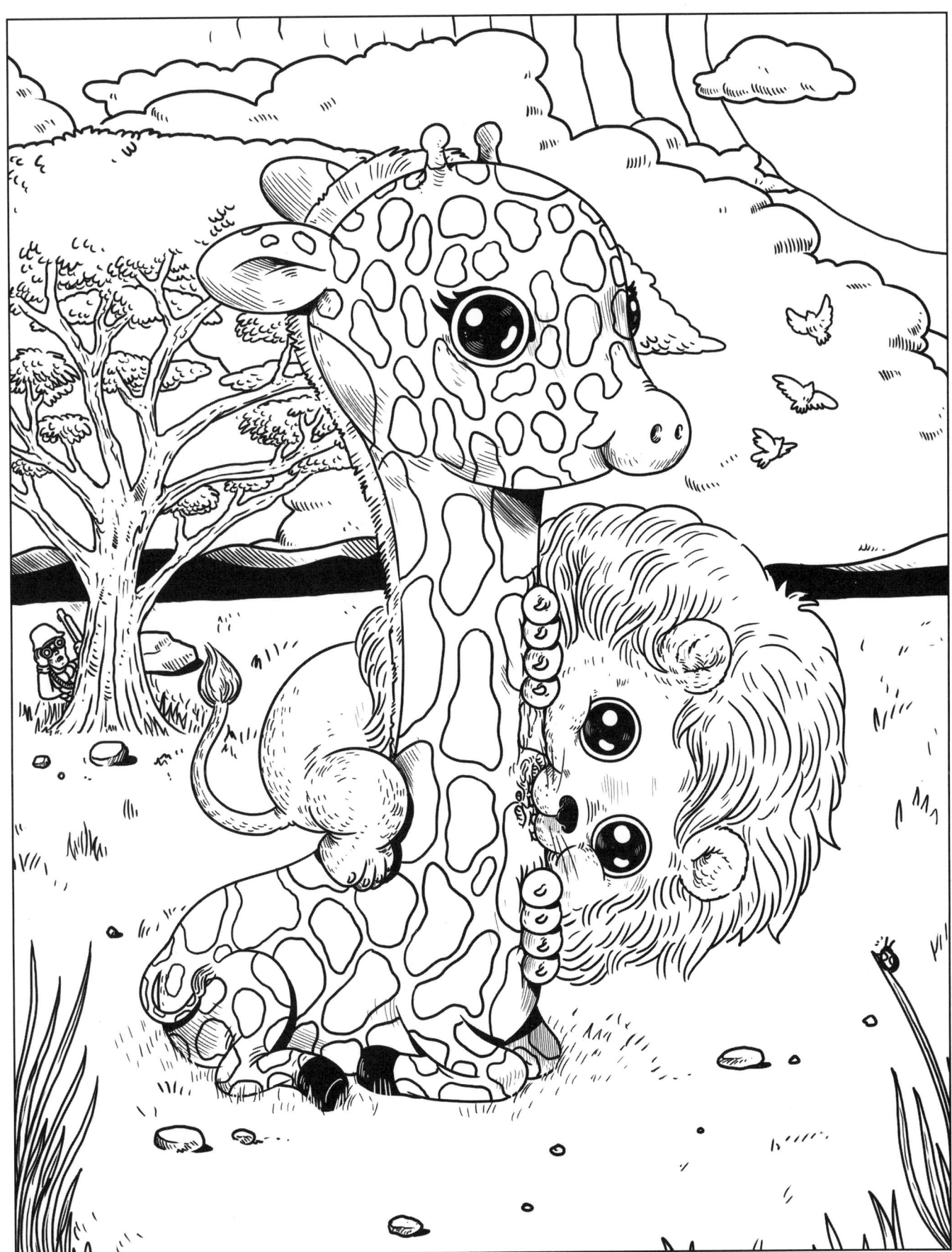

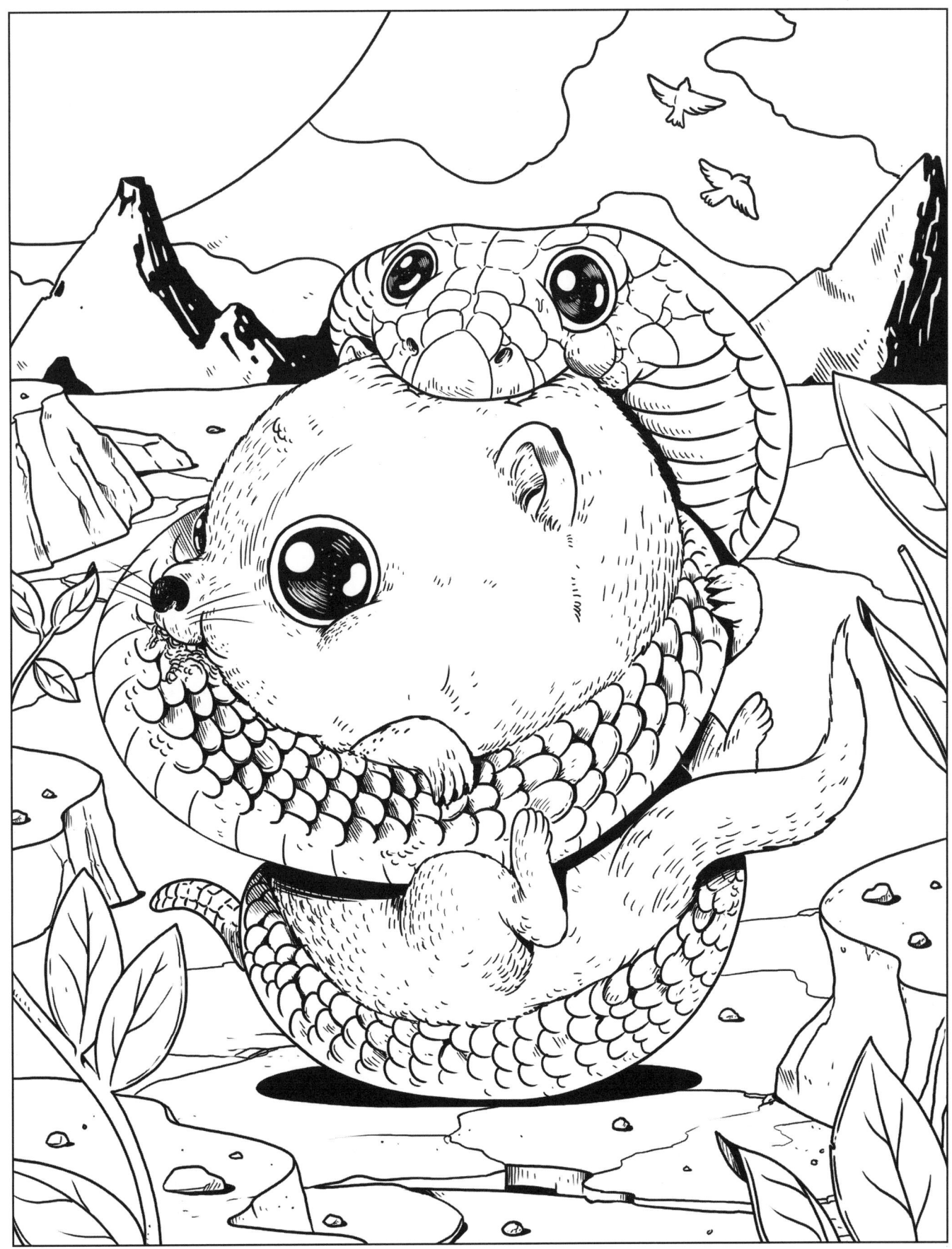

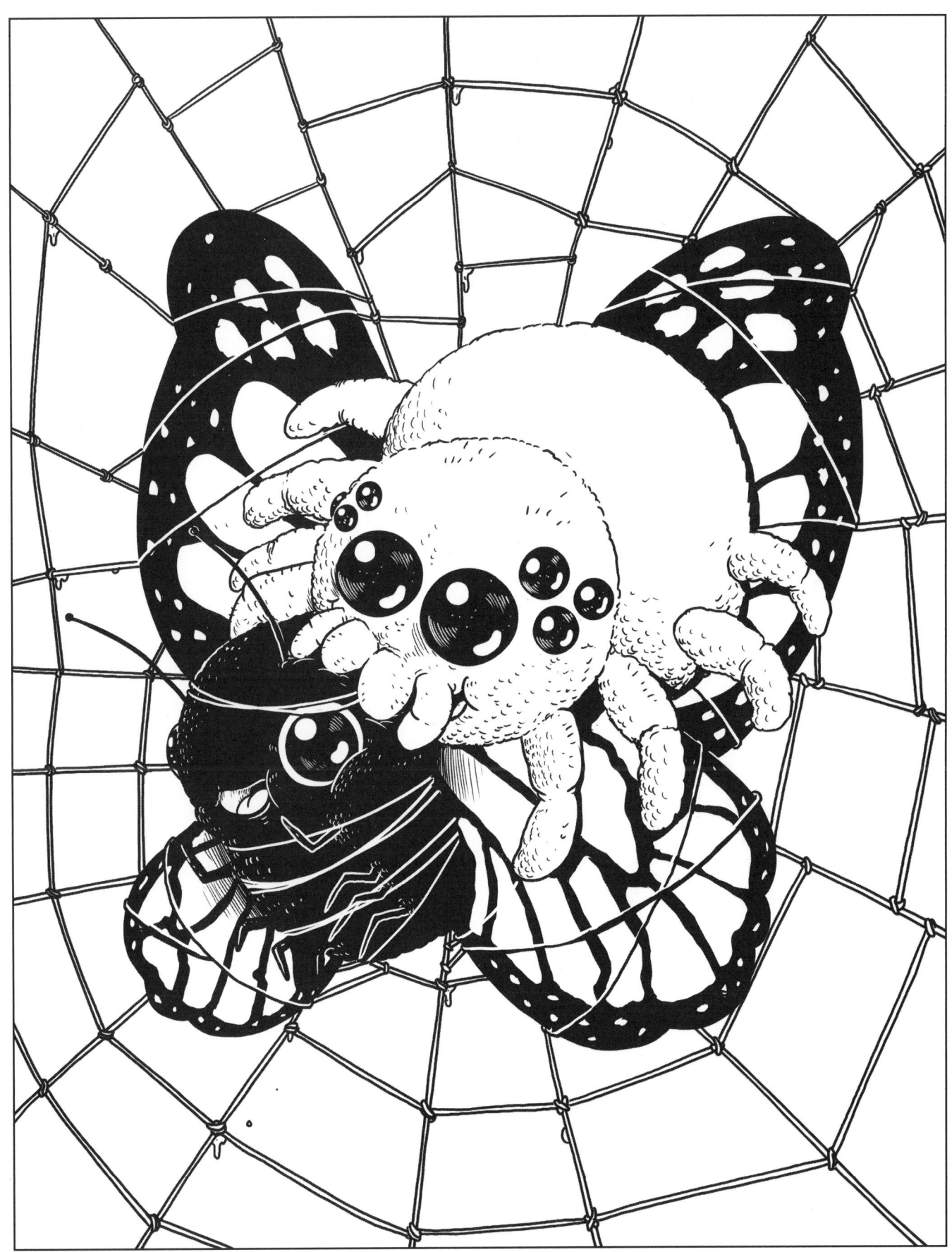

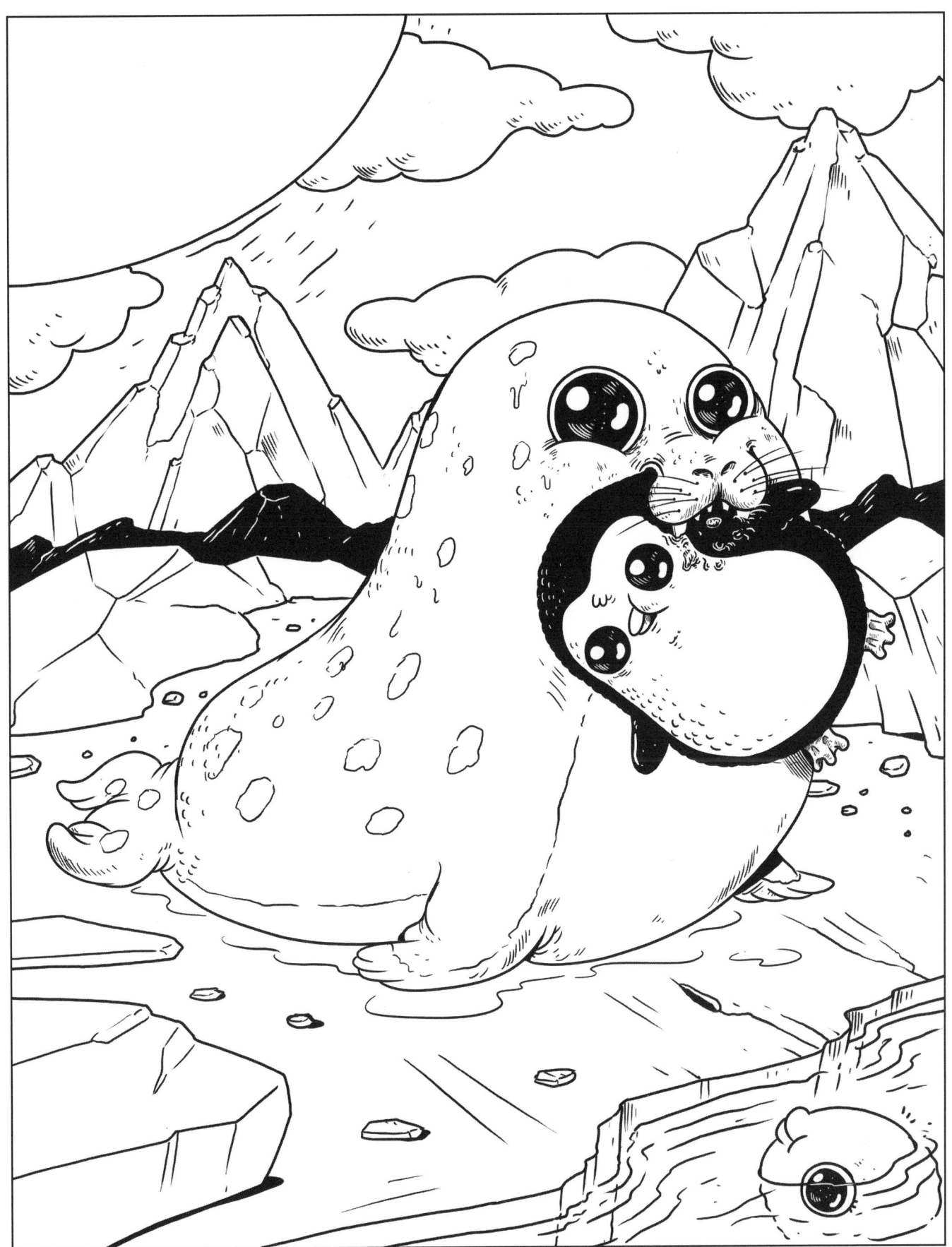

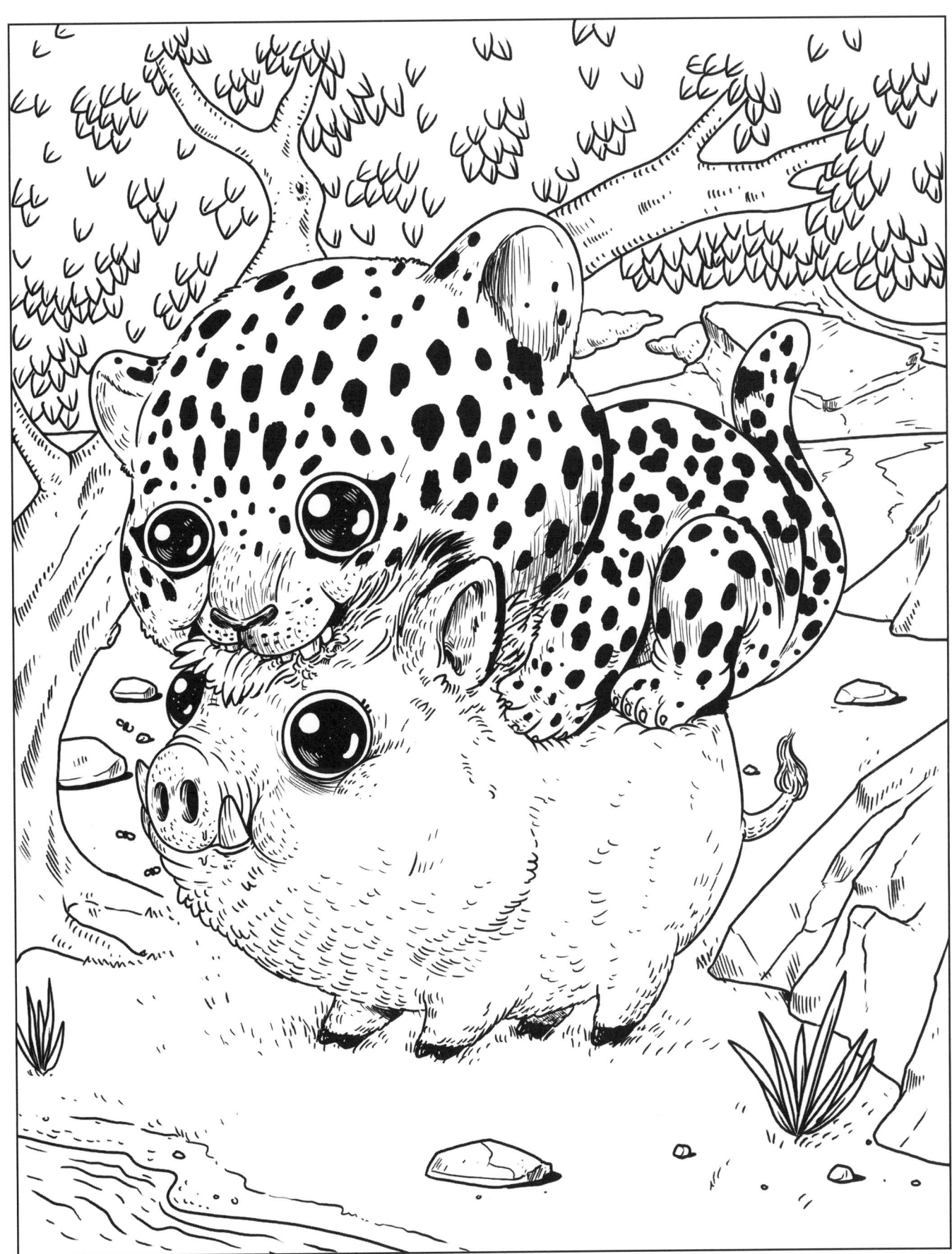

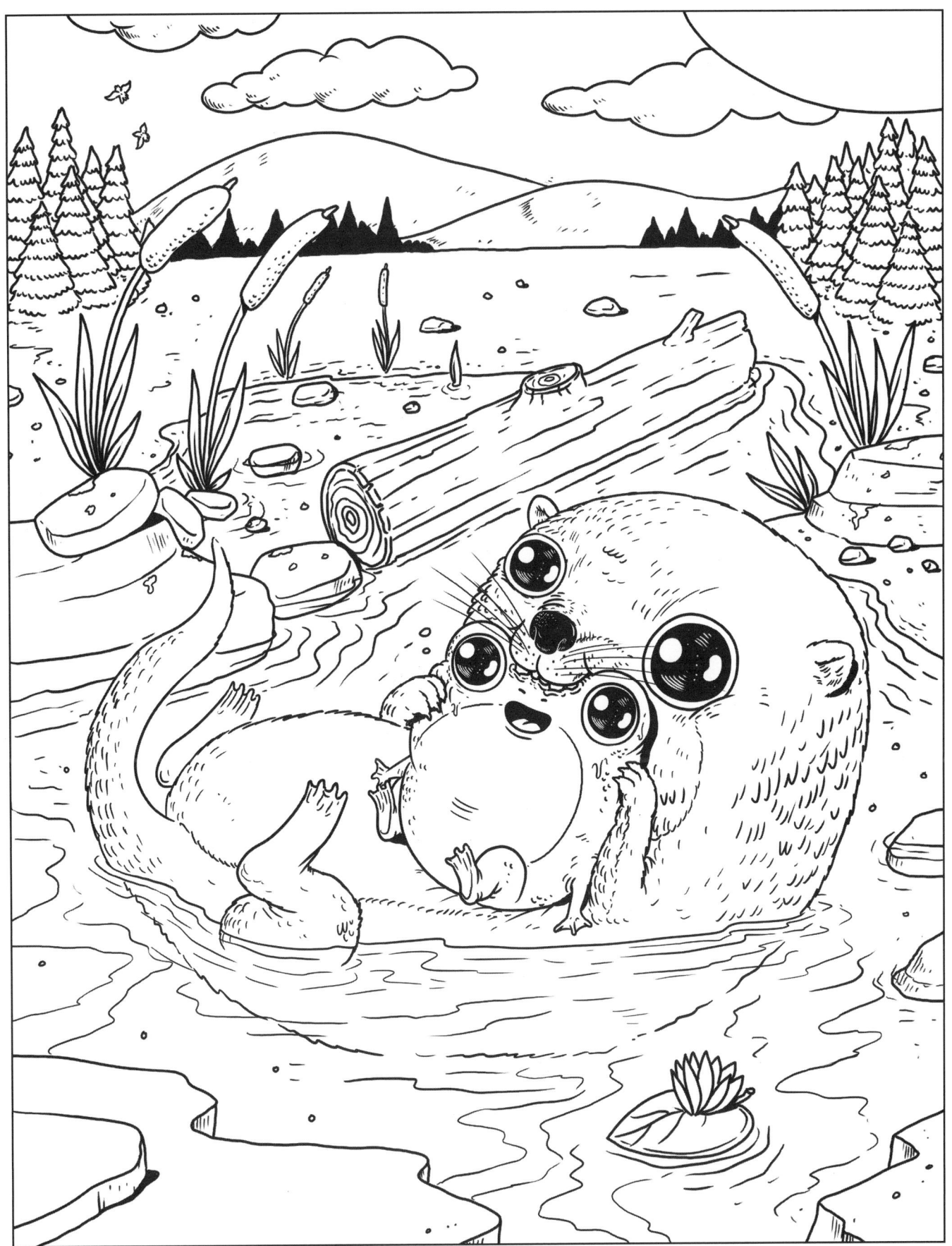

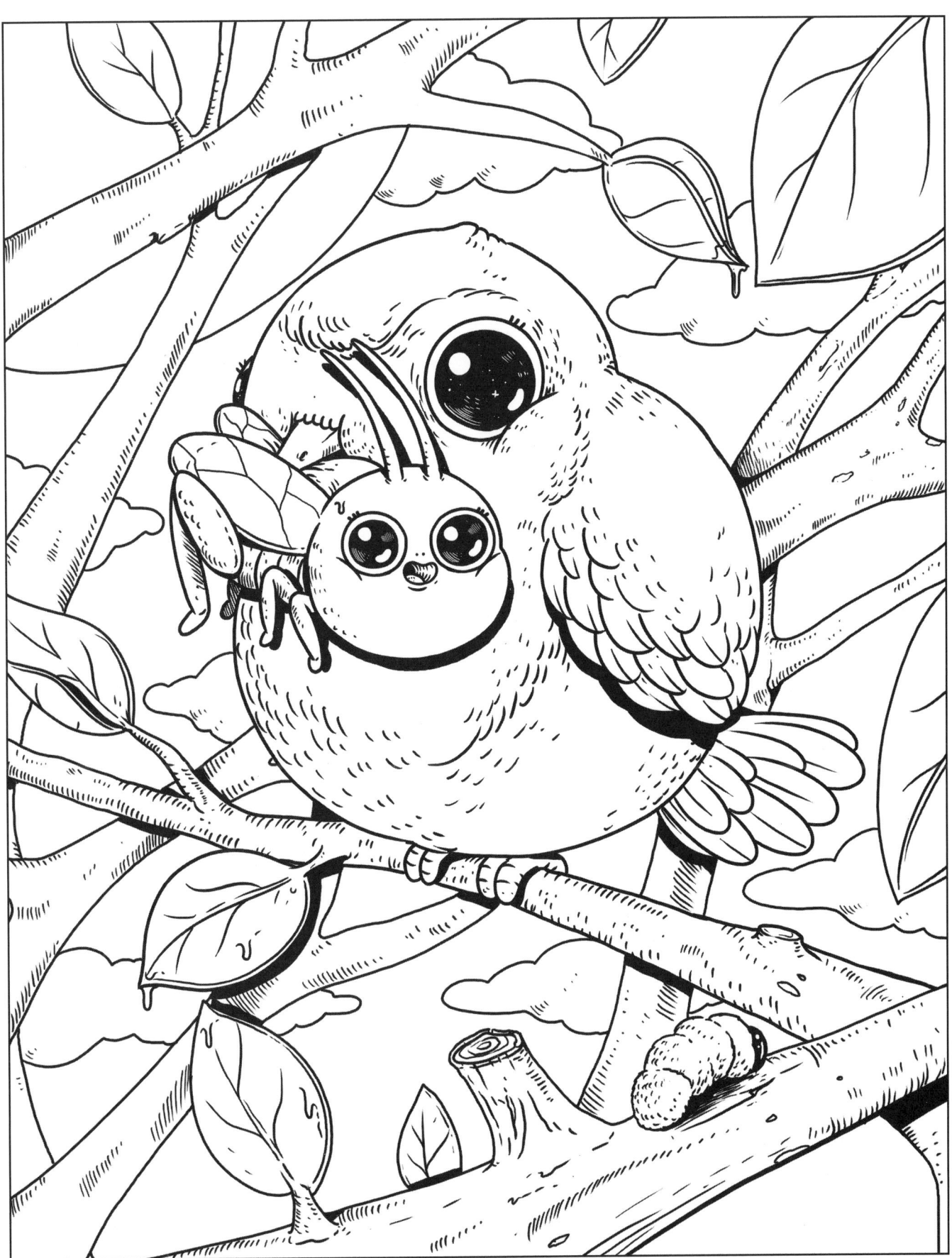

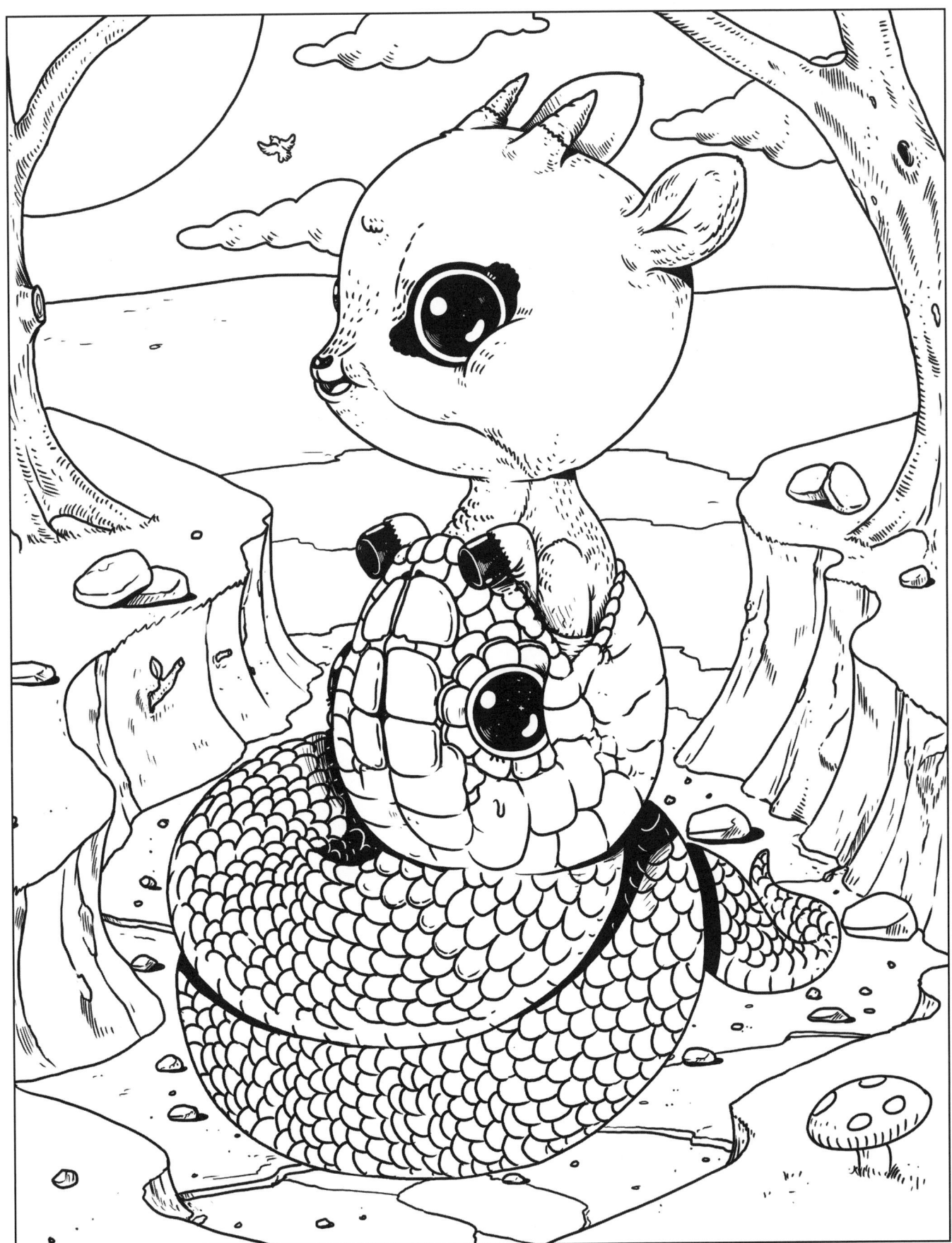

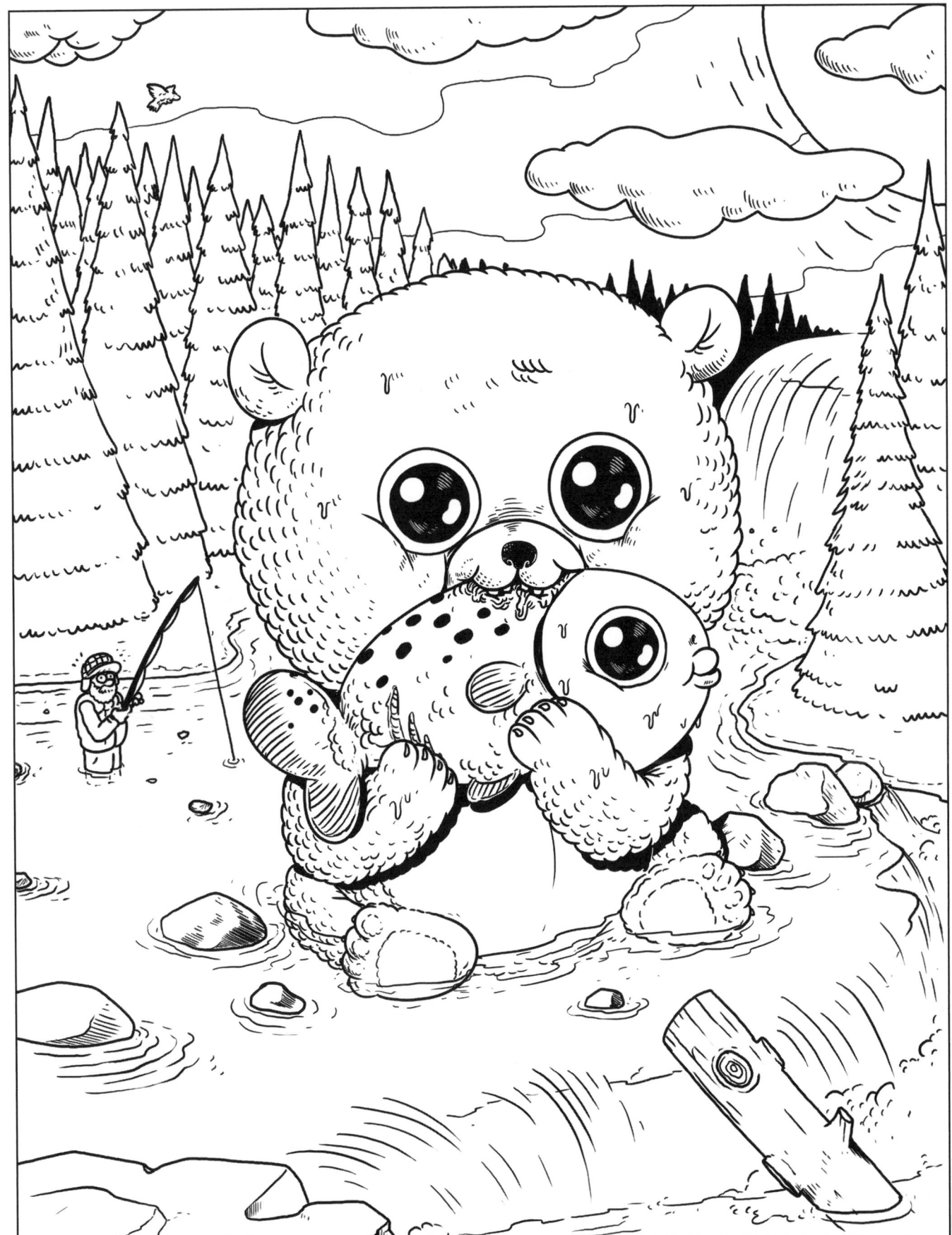

Alex Solis is an illustrator and designer, as well as a full-time husband and father.
Solis is bridging cultural gaps with the universal language of art,
as can be seen in his viral art series, including "Famous Chunkies,"
"Icons Unmasked," and the "Adorable Circle of Life."
You can see all his work online at oddworx.com.

Also Available from
Skyhorse Publishing

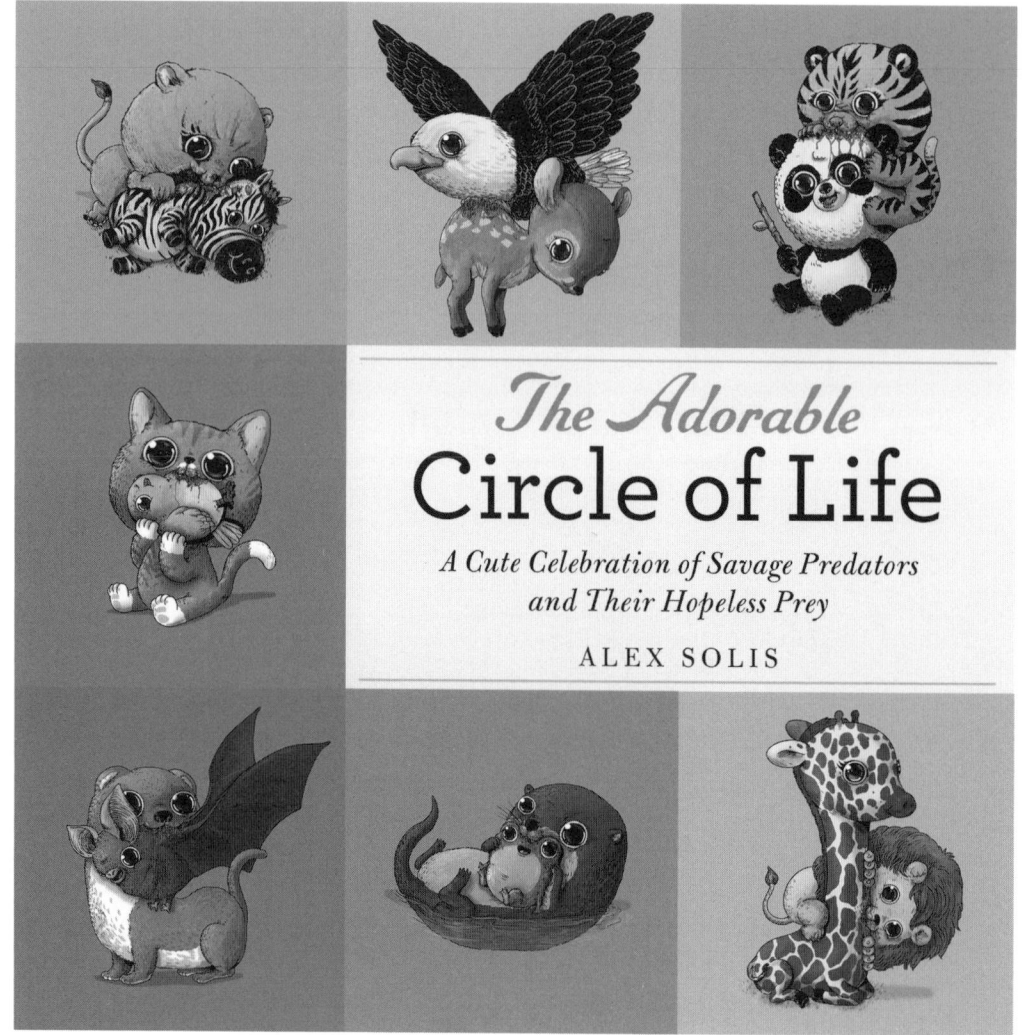